IMAGES
of America
NATIVE AMERICANS OF
SAN DIEGO COUNTY

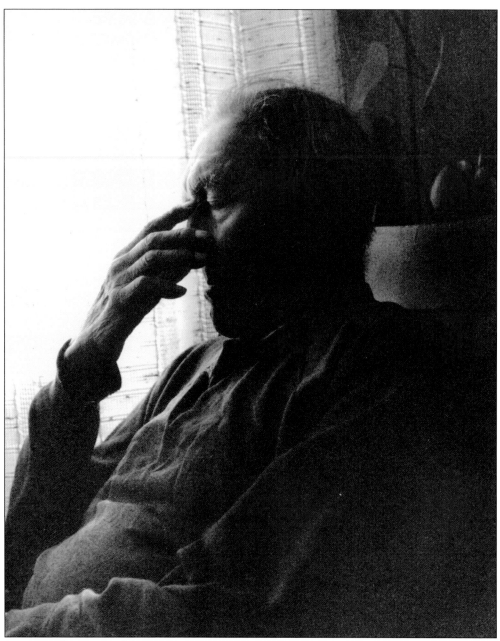

George Paul Martinez of the Kumeyaay Indians lived through many of the upheavals that happened the San Pasqual Band as they were removed from their lands and relocated, fought for water rights, acquired citizenship, acquired voting rights, and attempted to survive the infringement of their religious rights and ceremonies. (DMT.)

ON THE COVER: Luiseño and Kumeyaay (Diegueño) women from El Capitan Grande (now unoccupied as a result of the taking of the lands for El Capitan Dam) are dressed in full regalia at the Cabrillo celebration of September 1892 in downtown San Diego. Some customs required the painting of faces, which is what you see on these elders of the tribe. Behind them are housing styles of some Native Americans of the period. (MOM.)

IMAGES
of America

NATIVE AMERICANS OF SAN DIEGO COUNTY

Donna Bradley

ARCADIA
PUBLISHING

Published by Arcadia Publishing
Charleston SC, Chicago IL, Portsmouth NH, San Francisco CA

Printed in the United States of America

Library of Congress Catalog Card Number: 2008931761

For all general information contact Arcadia Publishing at:
Telephone 843-853-2070
Fax 843-853-0044
E-mail sales@arcadiapublishing.com
For customer service and orders:
Toll-Free 1-888-313-2665

Visit us on the Internet at www.arcadiapublishing.com

*To Danielle and Cheré, that you may better understand your heritage,
and Mike for your undying support while I was writing this book.*

CONTENTS

ACKNOWLEDGMENTS

Books such as these take the help and cooperation of many to bring them to fruition, and had it not been for the many who participated on this project, this work would have never been completed. The following people (in alphabetical order) are among those who helped to make this possible and have my undying gratitude. Note that those who have supplied photographs have initials on the corresponding photographs in the book: the Edward Curtis Collection from the Library of Congress (ECC); Shasta C. Gayghen, MA, assistant director of Cupa Cultural Center (CCC); Alexandra Harris, curator of Historic Media, Barona Cultural Center and Museum; Ken Hedges, San Diego Museum of Man (MOM); Native American Chamber of Commerce of Southern California; David Marshall (DM); Betty Rayfield, Warner Hot Springs (WHS); Carl Shipek, archivist, Kumeyaay Community College (CS); Dorothy Tavui, chairperson and elder, San Pasqual Band of Mission Indians (DMT); U.S. National Archives and Records Administration, Laguna Niguel (NARA); the author (DB); and finally, but far from least, Debbie Seracini, my editor who held my hand through this entire book.

INTRODUCTION

Native Americans have been known to populate San Diego County for a period in excess of 10,000 years. Today there are four basic tribal groups: Cahuilla, Cupeño, Kumeyaay, and Luiseño. They have been known by many names, but these are the names most recognizable today. Most of these aboriginal peoples lived in semi-permanent villages, traveling to forage for food and depending heavily on acorns, hunting small animals, and fishing. The native people of San Diego had no beasts of burden and did not use the wheel.

There were some conflicts between the tribes (primarily between the Cahuilla and Cupeño), but most were content in their lifestyles. Then, in 1542, Juan Rodriguez Cabrillo, an explorer sailing under the Spanish flag, landed in what became known as Point Loma and claimed the Native American lands for Spain. The year 1602 marked the arrival of Sebastian Vizcaino, who proceeded to name the bay and the primarily Kumeyaay lands "San Diego." At this point in history, the life of the natives would never again be the same.

El Presidio Reál de San Diego was built in 1769 upon the building of the first permanent village by the Spaniards and the arrival of Fr. Junípero Serra. Located in present-day Presidio Park, it was built with two cannons for protection, one aimed at the bay and the other at the Kumeyaay Indian village of Nipaquay. The natives of the time were referred to by the Spanish as Diegueños, referencing them to the location of San Diego, although they included primarily the Kumeyaay and Luiseño tribes. In 1774, the Franciscan Fr. Junípero Serra moved the San Diego Mission inland near the Indian village, and, using Indian labor, a new structure was built.

The Indians were originally made promises of improvements on their lifestyle in exchange for their labor, but as time progressed, the Indians were enslaved by the Spaniards and, under torture, were forced not only to work, but to convert to the Catholic religion.

The Indians considered the San Diego Mission to be an invasion of their territory, and after the broken agreements and maltreatment, a group of some 800 Indian men attacked and burned the San Diego Mission one month after completion in 1775.

Enslaved Indians again rebuilt the mission in 1776, and by 1778, the military commandant incarcerated Pauma tribal leaders to avert further Indian organizing efforts. By order of the Spanish courts, pressed by religious orders, Indian medicine men (shamans) were tried and convicted for witchcraft. In 1808, the Indians built the San Diego Mission Church under slavery conditions from the Spaniards. An earthquake in 1812 destroyed the new church, and the Indians again rebuilt it the following year.

Under the direction of the missionaries, Indians constructed and completed a dam and flume to capture water from the San Diego River for use by the mission. This nine-year project was completed in 1816. This dam is located in present-day Mission Trails Park although it is of no profitable use today.

From 1810 until 1830, the estimated number of Indians in the area decreased immensely from about 75,000 to approximately 16,000. Epidemics of European diseases decimated the natives, who had no resistance to measles, smallpox, and malaria as they had never been exposed before and

had not built up any antibodies. Also, with the slavery and mistreatment by the Spaniards, many died of malnutrition. Gov. Vicente de Sola of California reported in 1818 that 64,000 Indians had been baptized, but 41,000 of them were now dead.

With the independence of Mexico from Spain in 1821, California became part of Mexico. The Mexican Constitution of 1824 recognized equality of all Mexican citizens in the area, including the Indians, with Indians being defined as only "Christianized" Indians. Pagans could not be citizens. They promised secularization of the lands with the intent of eventually turning the California missions into Indian pueblos. Ranchos were granted throughout the area, most in Southern California, but they were given to wealthy Mexican citizens and not the Indians. The secularization was not complete until the 1840s, and for some of the mission lands promised to the Indians, ruin and desolation were all that was left.

The Indians actively resisted the expansion of the Spanish/Mexican rancho system in California. Indians who did receive any land allotments were few and were often forced to leave or sell the land because of lack of supplies or the actions of the unscrupulous officials. Skirmishes were commonplace, and many Indians were killed. When the Indians finally left the mission lands, most had no land or any means of livelihood. They raided and plundered ranchos for survival. Juan Bautista Alvarado, later a governor, stated it was his opinion that the missions "found the Indians in full enjoyment of their five senses, valiant in war, [and] far-sighted in their own way." But when the padres departed, "they left the Indian population half-stupefied, very much reduced in numbers, and duller than when they found them."

The Mexican ranchos of Southern California used primarily Indian labor to maintain their large grants of land, but they also treated the Indians much like slaves. Finally, in 1847, the Mexicans surrendered control of Southern California to the United States. Based on the international borders, this split the Kumeyaay Indian nation between two countries, north and south of the determined border. During the final skirmishes of the Mexican-American War, Gen. Stephen Watts Kearney led his forces to San Diego. Offered allegiance by the Kumeyaay, Kearney asked them to stay out of the "Battle of San Pasqual" and promised fairness and justice for the Indians under the United States. Kearney would have lost the battle except for Kumeyaay help. An Indian led Kit Carson and Lt. Edward Beale through enemy lines to Commodore Stockton in San Diego so 250 reinforcements could return to complete the confrontation with Andres Pico, thereby maintaining the lands from the Mexican Californios or rancho owners.

Under the Treaty of Guadalupe Hidalgo at the end of the Mexican-American War, Mexicans staying in the new U.S. territory were allowed to become U.S. citizens, but no mention was made of the Indians. By 1850, the California Legislature adopted a law declaring Indians to be vagabonds if they did not have local employment. They were therefore liable to be sold to the highest bidder as laborers for repayment of the fines incurred upon arrest for vagrancy and forced to serve double time as the fine they would have otherwise incurred. It was at this time that the State of California declared genocide on the Indian population, causing the population to decrease by about 90 percent.

From 1850 to 1860, some local Indians found employment as ship hands when San Diego became a port of call for schooners engaged in the whale trade. More commonly, work was difficult to find, and Indian laborers were paid one-third or less of the going wage. Eventually, some of the Indian women were forced into domestic service.

In 1851, Antonio Garra, a Cupeño leader residing in the village of Cupa, led a resistance of Indians from various tribes against the white man. This was prompted by the county's attempt to collect taxes from Indian tribes at Don Juan Warner's ranch. The ranch house, as well as the stage station in Oak Grove, was burned. Finally a rival Cahuilla chief captured Garra and turned him over to the authorities. With the failure of the revolt, Garra was found guilty of treason, murder, and theft in the aftermath of the Indian revolt and was executed January 17, 1852.

Meanwhile, Washington sent two emissaries to California to investigate the status of recognition of Indian lands in California. These men never spoke to a single Indian, spent $25,000 of government funds, and came back with an inaccurate report of no advantage to the Indians. Washington then

authorized three representatives to make treaties with the Indians. Once arriving in California and discovering the vastness of the territory, they split up and negotiated on their own. Few if any of the Indians could speak English, as they only spoke Spanish or Mexican Spanish and their native language. Despite this handicap, 18 treaties were negotiated and the men returned to Washington. On July 8, 1852, the Senate refused to ratify any of the treaties and filed an injunction of secrecy that was ultimately removed in 1905. This left the Indians believing they had a treaty and no one to tell them otherwise.

During the formation of the California Legislature, in Gov. John McDougall's first address to the legislature, he promised an extermination war against the Indians. Despite guarantees in the Treaty of Guadalupe Hidalgo, Indians were denied citizenship, voting rights, and more important still, the right to testify in court. Despite entering the union as a free state in 1850, California immediately enacted a series of laws legalizing Indian slavery. One of the laws sanctioned an indenture system like that of Mexican peonage, in practice throughout California prior to 1850. All levels of state, county, and local governments participated in this practice, which evolved into a heartless policy of killing Indian parents while kidnapping and indenturing the children. Indian youth could be enslaved to the age of 30 for males and 25 for females. A state law was passed in 1853 forbidding Indians from possessing firearms in California. The Common School Act of 1860 excluded Indian children from California public schools. In 1862, San Diego City Council ordered the sheriff to remove "the Indian rancheria one-half mile from any town residence." Following the Civil War, in 1866, Congress passed the Civil Rights Amendment, Article XIV, which became law in 1868. This act gave blacks citizenship rights but pointed out again that Indians would not be counted in apportioning U.S. representatives in Congress.

In 1870, Pres. Ulysses S. Grant signed an executive order granting San Diego's first Indian reservations. This executive order was revoked a couple years later and forced the Indians off their newly acquired lands. By 1877, there was a severe drought in San Diego, which resulted in attacks on the Indians holding water resources. By 1881, the first Indian school was formed in San Diego; the *San Diego Union* newspaper states it is to "instruct these young heathens." Congress passed the Indian Homestead Act in 1883 allowing Indians to homestead their lands, but it failed to notify the Indians, so most did not file homesteads. By 1884, Indians sent to a boarding school were not only denied contact with their families, but were forbidden to communicate in their native tongue. The Bureau of Indian Affairs (BIA) in 1887 forbade Indians from carrying out their ceremonies, practices, and medicine on the reservations. By 1896, the BIA ordered all Indians to cut their hair short to look less "Indian." By 1900, the population of Indians in all of California was only about 16,000, of which 11,800 were considered to be homeless.

In the early 1900s, the Cupeño Indians from Cupa attempted to maintain possession of their lands near Warner Springs. They lost in San Diego courts and took it to the Supreme Court, where again they lost their rights. By 1903, they were forcibly transported to the Pala reservation in a three-day "Trail of Tears" and settled among a distinctly different Luiseño people, with whom they eventually became integrated.

Although finally granted U.S. citizenship in the Snyder Act of 1924, when women (Indian and others) were also granted the right to vote, Indians still could not vote in local elections. In 1932, at the desire of land speculators and unknown to the Indians, Congress granted the City of San Diego permission to purchase the heart of the Capitan Grande reservation on which many Kumeyaay had built homes. They were forced off their ancestral lands on the San Diego River in order for the city to build the El Capitan Dam and reservoir. These Indians were relocated to what is today known as the Barona and Viejas reservations. In 1958, Interstate Highway 8 opened in February, following the ancient Indian trails through Mission Valley.

Since that time, the Indians of Southern California have slowly begun to win some rights as citizens. They now have grants for some lands, although much less than originally promised in the unratified treaties. Although forced many times to move, they are beginning to build nicer and more profitable lands and casinos that employ many of the white men who once enslaved them. They have acquired their citizenship and their full rights to vote. They have regained at

least some of their water rights for usage by their peoples on the reservations, and they have developed a means of acquiring funds for survival. Although heavily taxed on casino incomes (much more than any other income source by non-Indians), they take their residual income and help out their communities, regardless of race, religion, or creed. La Jolla reservation finally acquired electricity in 1998 as reported in the *San Diego Union* newspaper. The reservations that have income from casinos help the non-casino tribes when tragedies happen, such as the massive destruction of the San Pasqual reservation in 2003 and the La Jolla reservation in 2007 by the Southern California fires. They are a very giving people, proud of their heritage and the fight in which they have survived over the many centuries, but one thing they significantly ask for is that the truth be told of their history and heritage.

One

NATIVE AMERICANS IN SAN DIEGO COUNTY

Although known by many names, there are only four basic tribal groups of Indians within the 18 reservations or *rancherias* in San Diego County. Each of these is referred to as a band. Of these bands, there are two basic language groups but several dialects.

Cahuilla Indians are primarily located on Los Coyotes. Most of the Cahuilla Indians are located in Riverside County. Cupeño Indians are a very small tribe and are primarily located on Pala and Los Coyotes. Luiseño Indians are primarily located on the La Jolla, Pauma, and Rincon reservations and into Riverside County. These three tribes are commonly referred to as the Southern California Shoshone because of their Takic language family of the Uto-Aztecan.

Kumeyaay Indians are also known as Diegueño, Ipai, Tipai, or Mission Indians. Diegueño is a name given by the Spanish and also includes some Luiseño (also named by the Spanish). Mission Indians is a name for all those affiliated with the missions during the Spanish period and included several tribal affiliations of the time. Kumeyaay are of the Yuman language family, Hokan stock, of which Ipai dialect is in the northern county and Tipai dialect in the southern county. Kumeyaay lands actually extend into Baja California (Mexico), where they are referred to as Kumiai. Some research shows that Kumeyaay were originally Kamia of Imperial County. Being the largest population of Native Americans in San Diego County, they are primarily affiliated with the following bands: Barona, Campo, Capitan Grande (currently unoccupied), Cuyapaipe, Inaja-Cosmit, Jamul, La Posta, Manzanita, Mesa Grande, San Pasqual, Santa Ysabel, Sycuan, and Viejas.

The Native Americans are survivors to say the least. They strived for equality but had their lands stolen from them and were not granted citizenship until 1924, nor had they the right to vote until that time and, in some cases, even later. They were treated as slaves from European contact until well into the 1900s. Some did not even have electricity in their homes until 1998, only a decade ago. This brief history will educate many on the true story of the Indians of San Diego County area.

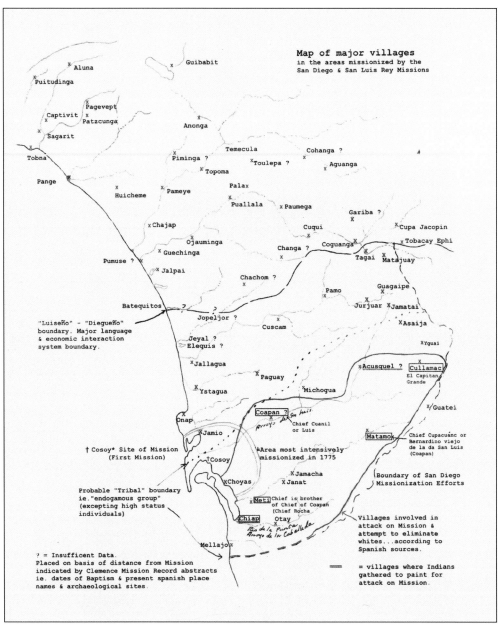

Map of major villages in the areas missionized by the San Diego & San Luis Rey Missions

x Aluna
x Puitudinga
x Guibabit

x Pagevept
Captivit x Patzcunga
x Sagarit
x Anonga

Tobna
Pange
x Huicheme x Pameye

Temecula
x Piminga ?
x Topoma
Palax
Puallala

Cohanga ?
x Toulepa ?
x Aguanga
x Paumega
Gariba ?
x

x Chajap
x Ojauminga
x Guechinga
Pumuse ? x
x Jalpai
Cuqui
x
Changa ?
x
Coguanga
x
Cupa Jacopin
x Tobacay Ephi
Tagai Matajuay
x x

Chachom ?
x
Pamo
x
Guagaipe
x

Batequitos
"Luiseño" – "Diegueño" boundary. Major language & economic interaction system boundary.
? Jopeljor ?
Jeyal ?
Elequis ?
x Jallagua
x Ystagua
Cuscam
x
Paguay
x
Michogua
x
Jurjuar x Jamatai
x Asaija
x Yguai
x Acusquel ? Cullamac
El Capitan Grande
x Guatei

† Cosoy* Site of Mission (First Mission)
x Onap
x Jamio
† Cosoy
Coapan ?
on hill
Arroyo
Chief Cuanil or Luis
*Area most intensively missionized in 1775
Matamok
Chief Cupacuanc or Bernardino viejo de la da San Luis (Coapan)

Probable "Tribal" boundary ie. "endogamous group" (excepting high status individuals)
x Choyas
x Jamacha
x Janat
x Meti
Chief is brother of Chief of Coapan (Chief Rocha
Chiap
Otay
Rio de la Punta
Arroyo de la Caballada
Mellajo x

Boundary of San Diego Missionization Efforts
Villages involved in attack on Mission & attempt to eliminate whites...according to Spanish sources.

? = Insufficent Data.
Placed on basis of distance from Mission indicated by Clemence Mission Record abstracts ie. dates of Baptism & present spanish place names & archaeological sites.
= villages where Indians gathered to paint for attack on Mission.

This map shows some of the major Indian villages with Indian names located within San Diego County; these were missionized by the San Diego de Alcalá and Mission San Luis Rey Missions. This computer-enhanced version of an original hand-drawn map is on file in the Florence C. Shipek Collection, Kumeyaay Community College Archives. (CS.)

In appearance, Native Americans are not any different from any other person. They have high family values and goals of happiness and success for themselves and their families. So why were they treated so differently than others? Irene (Lawson) Martinez and George Martinez from San Pasqual are pictured here about 1955. (DMT.)

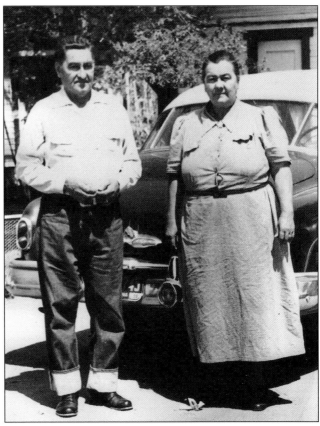

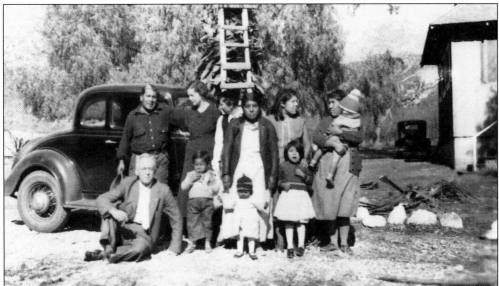

White men and women are standing with an Indian family to have this photograph taken. There was a time when friendly association with the Indians was cause to be questioned for treason by the white man. As time progresses, many of the attitudes have improved, but not vanished. (NARA.)

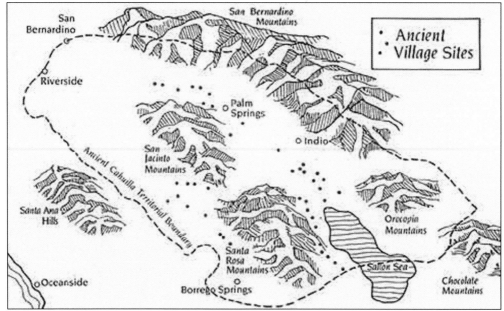

This map shows the ancient village sites of the Cahuilla Indians. Note that there is only minimal Cahuilla Indian territory actually in San Diego County. There is only one current-day reservation for the Cahuillas located within the county—Los Coyotes, located in the hills near Warner Springs—and that has as many Cupeño as Cahuilla residing there. (DB.)

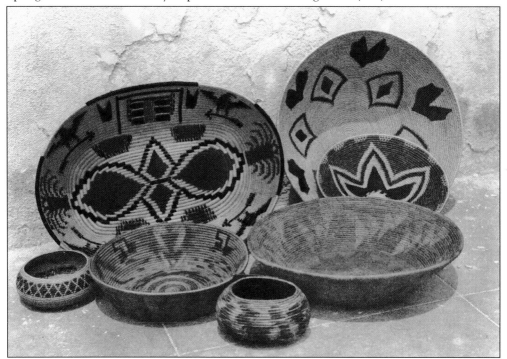

Cahuilla Indians are noted for their beautiful, artful, and useful basketry. Each basket is made for a specific purpose, and each artist has his or her own signature in the designs of the basketry. (ECC.)

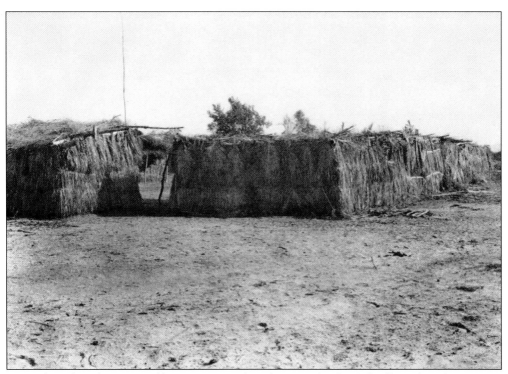

From the Edward Curtis Collection comes this photograph of a Cahuilla Indian fiesta camp taken in the early 1900s. Edward Curtis took many photographs of Indians and their habitats and lifestyles throughout the United States. (ECC.)

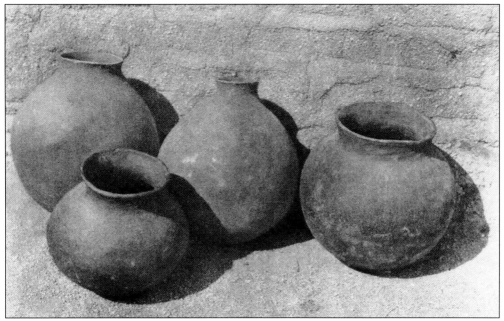

Another Edward Curtis photograph depicts some of the pottery made by the Indians at the dawn of the 20th century. Made from clay, these were used for carrying water from the river to the campsite to be used for drinking and cooking. (ECC.)

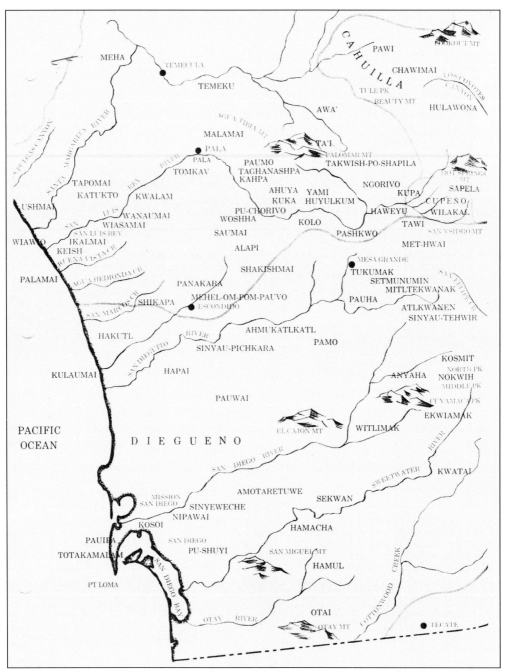

Note that in this map, the Luiseño and Kumeyaay Indians are collectively referred to as *Diegueño* Indians. Diegueño was the term given to all Indians affiliated with the San Diego Mission de Alcal by the Spaniards during the mission period. This is a more coastal map of the Indian villages. (WHS.)

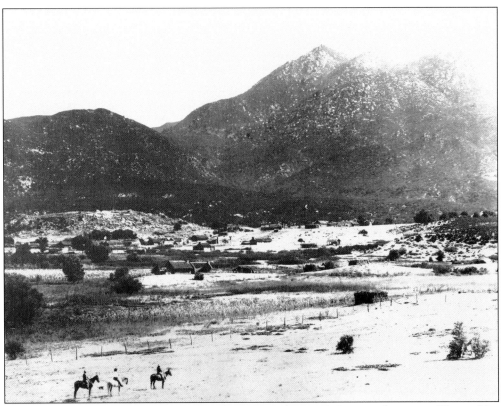

This is the Indian village of Cupa before their removal in 1903. It is now known as Warner Hot Springs and today is a privately owned resort. The original adobe buildings have been renovated but are still in use as resort cabins. (WHS.)

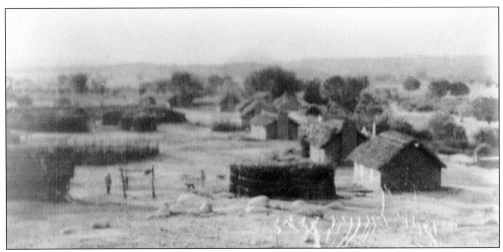

A closer view of the Cupeño village shows the adobe houses with thatched roofs. Cupa was also known as Aqua Caliente (meaning "hot water") Village because of the natural hot springs in the area. These have been the ancestral lands of the Cupeño for many, many years. (WHS.)

Indian leaders are not called "chiefs" anymore; they are known as a chairperson and each reservation has one. This is Felix QuisQuis, past chairperson of the San Pasqual Band of Kumeyaay Indians. (DMT.)

After the time of the Franciscan padres from Spain, religion became a vital part of the Indian way of life. This is a brush church in 1897 on Mesa Grande reservation with a social gathering of people either before or after the function. (MOM.)

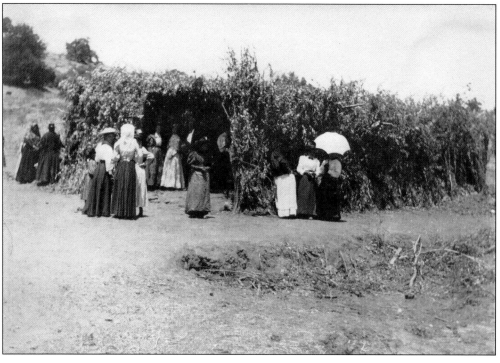

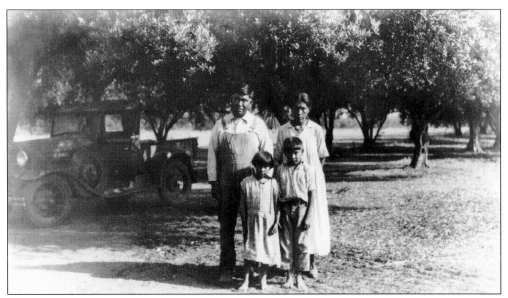

This is a family photograph of the Lachappa family from the Kumeyaay Band of Barona Indians on what appears to be the Barona reservation. (NARA.)

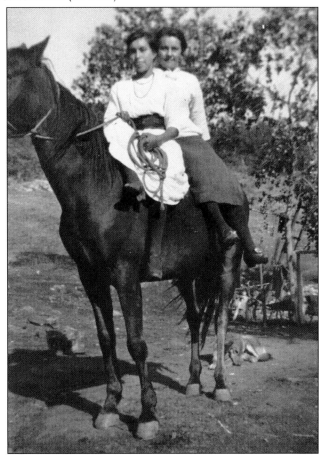

Irene Lawson (left, age 17) and Grace LaChusa (right, age 21) are horseback riding double and sidesaddle at Mesa Grande reservation about 1918. (DMT.)

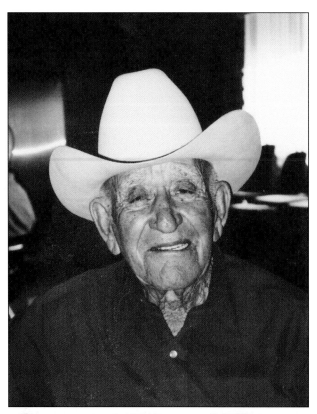

Eddie Guachino was an elder at the Santa Ysabel reservation, located in north San Diego County. In the Indian customs, it is not only age but wisdom that makes a person an elder. Elders are always consulted when major issues or questions need answers within a tribe. They also pass on the stories of the old ways and customs so they are not forgotten. (DMT.)

This 1936 photograph shows some of the Indians from the Barona Band of Kumeyaay Indians at the Barona reservation. (NARA.)

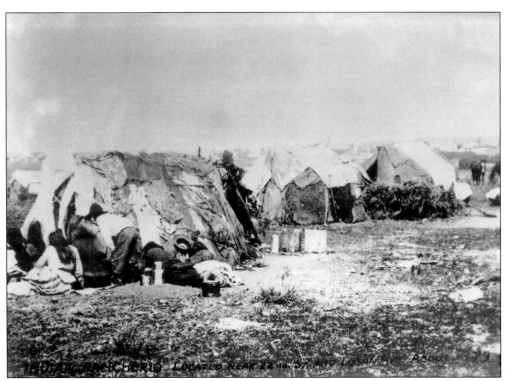

An Indian *ranchia* from 1879 was located near what are today Twenty-second and Logan Streets in the city of San Diego. A ranchia is a small village usually built for the purpose of housing a group of Indian workers. (MOM.)

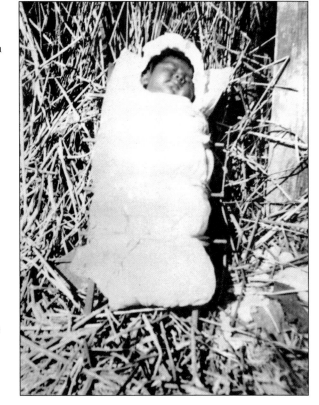

At the Mesa Grande reservation in 1904 is Lorencio Pachito's baby bundled on a cradle board. A papoose is an English word intended to mean "an Indian child" (regardless of tribe). The term also refers to cradle boards and other child carriers used by Indians. It is not an Indian word. (MOM.)

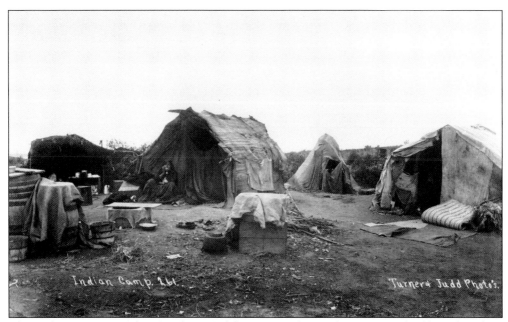

This Indian campground in Southern California is made up of various size buildings based on the number of inhabitants living inside each one. This is only a temporary camp, probably used for hunting or gathering of necessities for the winter storage of foods. (MOM.)

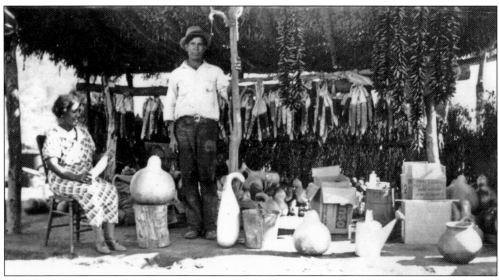

Medelona Costilla and her husband are selling many wares of pottery, basketry, and other handicrafts from a roadside stand on the Pala reservation about 1936. This was a common means of Indians making an income from their arts. (NARA.)

Two

THE WAY WE WERE

Many of the Indian ways and languages have been lost over the years. Botanically alone, there are hundreds of medicines once used by the shamans that have disappeared during the unwilling transition of the Native American to the white man's standards. Although photographs are not available for the pre-Spanish period, some of the old practices can be viewed of post–Civil War Indian customs. Some photographers took pictures of the everyday routines of the various tribes throughout the United States, including Southern California, which have helped others understand the everyday life of the average Indian in San Diego County.

Many of the modern religious practices of the Indians came from the Franciscan friars forcing their religion on the natives by order of the Spanish court system. Ceremonies of the natives have been lost because they were forbidden to practice their old ways. As they were hunters and gatherers, the Indians had to be taught to plant or tend fields and were often enslaved to do so on mission lands, therefore teaching them to farm. They learned of domesticated herds of cattle, goats, and sheep for hides and food and the fencing of their lands to corral their animals. Children were taken from their Indian families, removed from their influence, and placed into boarding schools where their Indian customs and language were forbidden, again being forced to learn the white man's ways and forego their own heritage.

This chapter will focus upon the simple chores of life such as preparing food, bathing, laundry, basketry, and the construction of homes, which were first built of thatch and later adobe (a skill they learned from the Spanish) for a more permanent structure.

The artistry in the basket works will also be explored, as well as a glimpse into some of the old ceremonies and practices that can still be remembered by the elders.

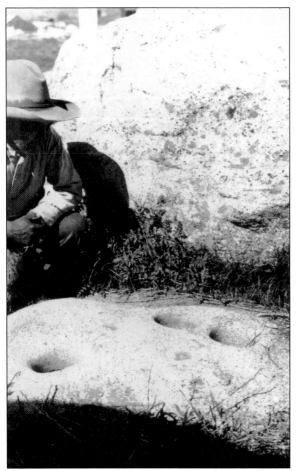

Although the Spanish Padres were given credit for the grinding of corn, this rarely happened, as the Indian slaves were entrusted with this task. Using handheld rocks called manos, the Indians would grind the corn or acorns in metates, which were holes formed in boulders worn by the continuous grinding. The friction between the mano and the metate would grind the corn or acorns into fine grains. Mortars and pestles are commonly mislabeled as used for grinding grain, but these were primarily used for medicinal purposes and not grains. A mortar was almost like a small rock bowl, and the pestle had the same action as a mano used for grain. At left are metates from the Pala reservation, and below are metates seen on the rocks near Warner Hot Springs, which could have been used by either the Cupeño or Cahuilla Indians. (Left, NARA; below, WHS.)

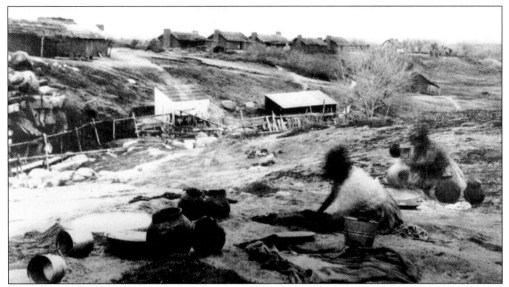

To prepare acorns for cooking, the hard shells were first removed and the acorns were put into metates. Using the manos, the acorns were pounded and ground into a fine meal that was sifted and placed into other holes in the metate lined with wild grapevine leaves. Hot water was poured over the meal in order to leach out the bitterness. The meal was then allowed to dry on leaves and took on the appearance of flat cakes. This was eaten as a bread or mixed with water into a mush. Above are Indians leaching the meal near Warner Springs; at right, the meal is being sifted through near Mesa Grande. (Above, WHS; right, MOM.)

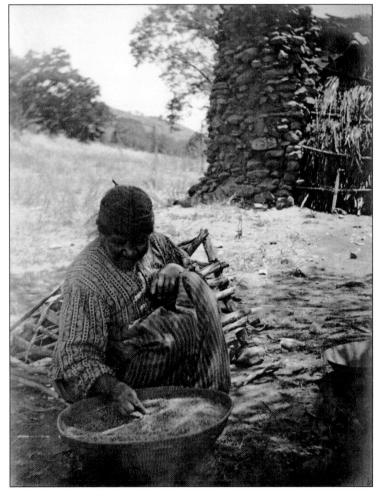

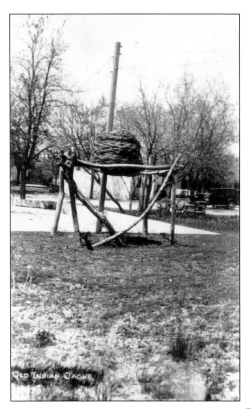

A cache was a large food container used for storage of both processed and unprocessed grains. When the Indians gathered their acorns, they would usually get more than what was required for the meal they were going to prepare. Overages were placed in caches for use during the winter months or when the grains were not readily available. Caches were usually woven from reeds or grasses and could be fairly large in size as they were used for the entire village. They were then placed well above the ground to prevent animals from raiding the cache of stored grains. At left and below are examples of caches of the Cupeño and Cahuilla Indians near Warner Ranch. (Both, WHS.)

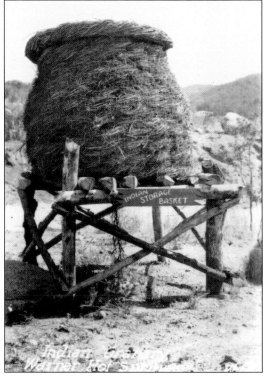

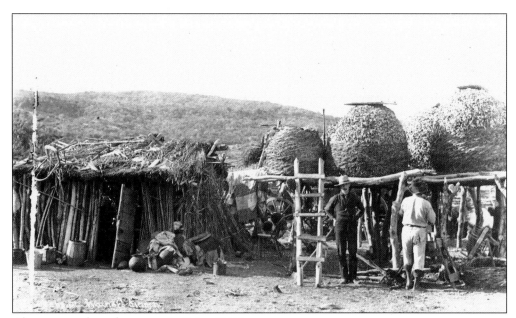

Above are caches of grains near the ramadas by Warner Ranch. This illustrates how high off the ground the caches were placed on stilts. Hunting was another means of acquiring food for the Indians. At right is a group of hunters near the Manzanita reservation. Once the meat was acquired, overages were then dried into a jerky, and that was also placed in caches or, at times, wrapped and buried until it was needed. During raids by the white man on the villages, especially during times of famine or drought, caches were looted and the contents taken back to white families. (Above, WHS; right, MOM.)

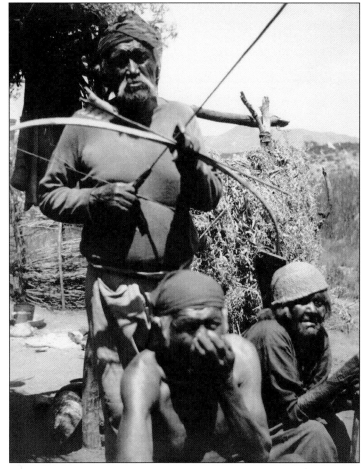

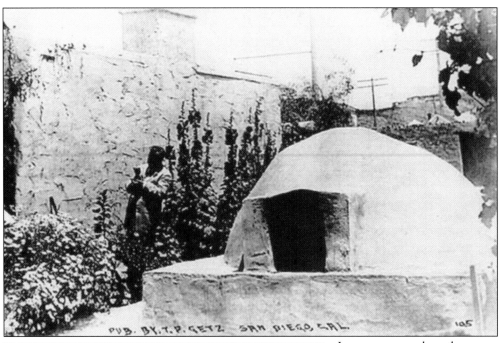

PUB. BY T. P. GETZ SAN DIEGO, CAL. 105

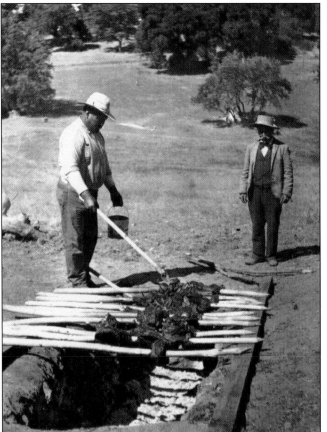

Large ovens, such as the one above on display at Ramona's marriage place (Estudillo house) in Old Town San Diego around 1920, were built of clay or adobe and used primarily for baking breads or cakes. As seen at left, meats were often cooked over a pit similar to a barbeque. Here the pit is a rectangular hole for the fire, with wood spikes laid across, usually spearing through the meat for slow cooking. Overages of meat were allowed to continue to slow cook until dried for winter storage. Although women usually tended the ovens, men usually tended the pits and maintained the fires during the cooking of meats. (Above, DB; left, MOM.)

Water was very important to the Indians of Southern California, and for this reason villages were located near rivers or streams. In the case of those living in mountain or desert lands, lakeside villages were common. Above is a bathhouse near Warner Ranch, which was used for bathing, usually by women, and afforded some privacy. Below can be seen the activity around the hot springs. Water was used for cooking, bathing, laundry, and many other chores. The hot springs near Warner Ranch maintains a water temperature of about 130–140 degrees. (Both, WHS.)

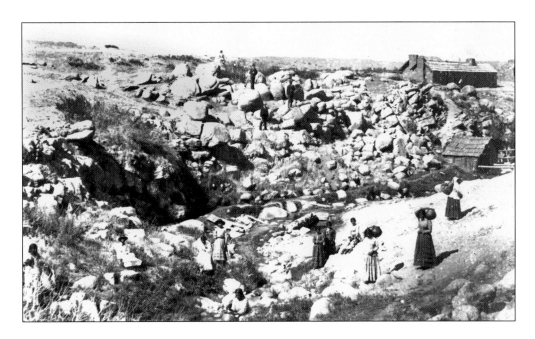

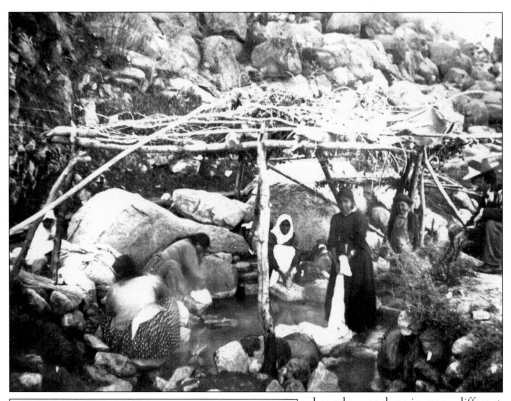

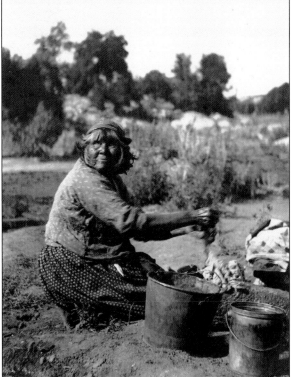

Laundry was done in many different ways depending upon the setup available to the Indians. Above note the women washing their laundry in the warm waters of the hot springs. At left, this Indian from Campo reservation is using a two-bucket method to wash the clothes. Obviously, the second means is much more difficult, but if the water source was not readily available, the laundry still had to be done. (Above, WHS; left MOM.)

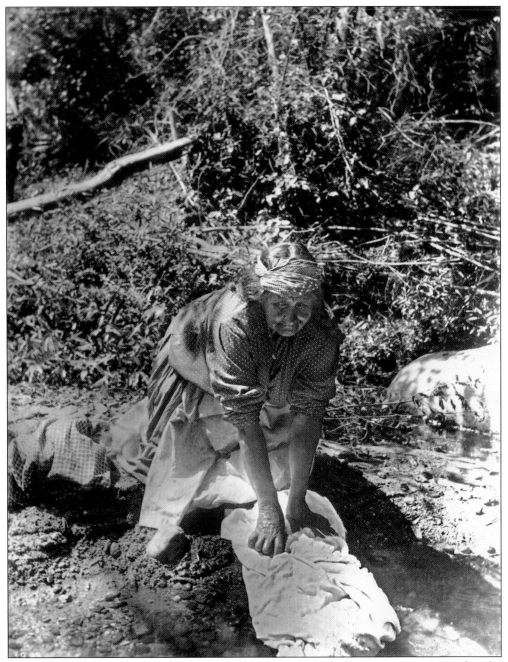

This Indian woman from Pala reservation is doing her laundry by a river or stream. Note that she is rubbing the dirty laundry against a large rock to help remove the dirt in the clothes. Is that a ramada or brush house behind her? Sometimes they are difficult to see because they blend in so well with the surroundings. (MOM.)

Making baskets is an Indian woman's pastime as well as a means of furnishing the kitchens of their homes. The above women are making baskets; at left, Grace LaChusa is displaying some Kumeyaay baskets. Note the variety of sizes. Baskets were made depending on their usage, such as gathering, cleaning, sifting, and the many other food preparations. Baskets were made to hold treasured possessions, and some were so tightly woven that they are even capable of holding water, although pottery was mostly for this purpose. Tighter woven baskets were also used for mixing grains with water to prepare acorn mush. (Above, WHS; left, DMT.)

Concepcion Osuna of Santa Ysabel is sorting, stripping, and preparing materials for basket making. The better the quality of materials, the better the baskets could be made. Since these baskets were used for prolonged periods of time, good quality and preparation were very important. (MOM.)

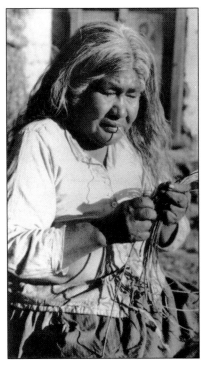

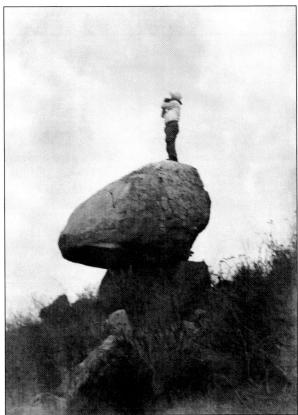

This photograph, taken at San Pasqual in 1902, shows a man standing on what was referred to as "The Calling Rock," which was used as a common means of communication between small villages or groups of families. He would cup his hands around his mouth to direct the sound toward the village he was calling. (MOM.)

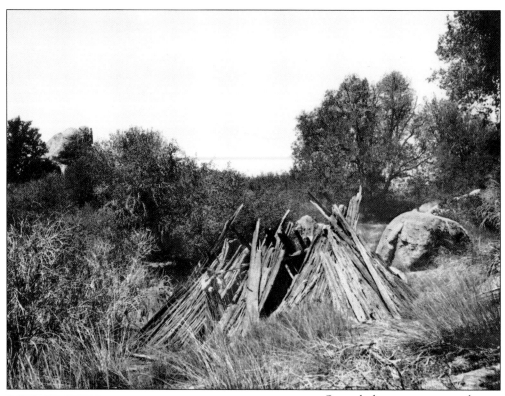

Sweat lodges were commonly used among the Indians, even before the arrival of the white man. They not only provided a means of bathing but also a cure for illness, as revitalization of the aching muscles, and as a place for ceremonial practices. But sweat lodges were primarily used to cleanse the body by purging it of impurities. The white man saw these lodges as a threat because of the sacred and religious implications they portrayed. Christian missionaries and government officials systematically denied the Indians the use of sweat lodges for many years. Above is a Cupeño sweat lodge and at left is a Cahuilla sweat lodge, both from the Warner Ranch area. (Above, MOM; left, WHS.)

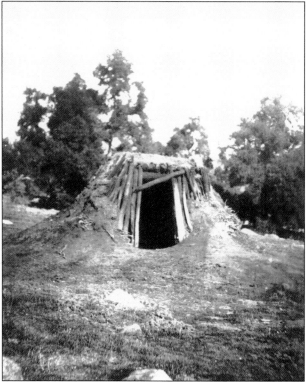

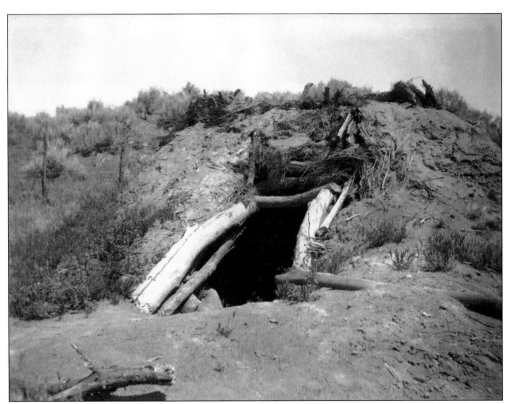

Above is a Luiseño sweat lodge. Preparation for a sweat bath and its indulgence followed traditional disciplines, often conducted by a medicine man. Hot rocks were placed inside the structure and periodically sprinkled with water, giving the sauna effect required. The number of hot stones and traditions vary by tribe and tradition, with each representing the customs of the specific tribe. (MOM.)

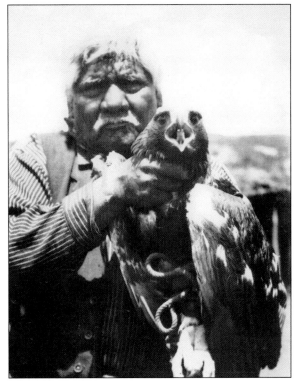

Narcisso LaChapa is holding a live eagle at Mesa Grande reservation between 1900 and 1920. Most Native Americans attach special significance to the eagle and its feathers. Images of eagles and their feathers are used on many tribal logos as a symbol of the Indian. To be given an eagle feather is the highest honor awarded within the indigenous cultures. Eagle feathers can also be a sign of rank and are often used in various ceremonies. (MOM.)

Henry Rodriquez, a La Jolla cultural leader, is shown here with a ceremonial dancer. Ceremonial dress was made of beading and feathers representative of the individual tribes. Most Native Americans can see the design and artwork in the clothing and know which tribal affiliation it applies to. Costuming is different for the various ceremonies as well. (DMT.)

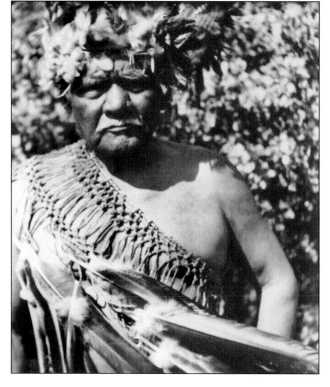

Narcisso LaChapa, a Kumeyaay of the Mesa Grande reservation, is seen here, bare-chested with a feather headdress and wearing an eagle feather kilt bandolier fashioned across his right shoulder. Preparing for a ceremony requires many rigid protocols to maintain good omens during the dance and to be prepared for the spirituality required. (MOM.)

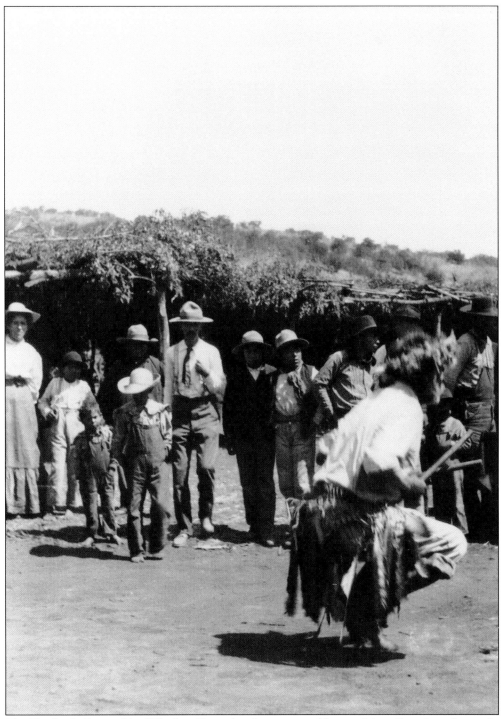

The Tatahuila Dance (the Whirling Dance) is demonstrated here at Mesa Grande in front of a large community ramada. This dance is also known as the Tapakwirp Dance and is part of the Diegueño mourning ceremony. The only indication that this is a mourning ceremony is the daughter of the leader, or kwaipai, wails for some time each afternoon before the dance. (MOM.)

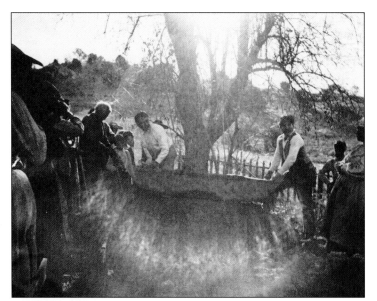

The funeral of the last hereditary Luiseño chief, Cinon Duro (Hokoyel Mutawir), seen in the wooden coffin, is taking place at the Mesa Grande reservation. Burial customs throughout California are basically the same, but the ceremonies vary by tribe. Prior to the arrival of the Spaniards, most of the Indians cremated their dead. The white man taught the Indians how to bury the dead. (MOM.)

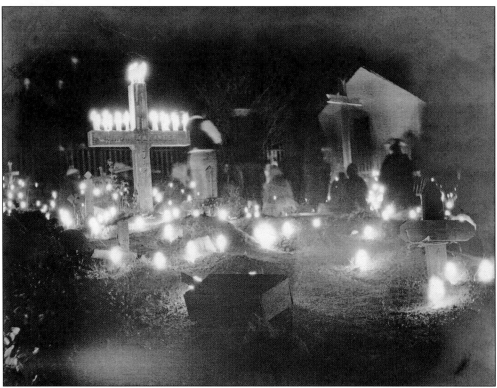

With the arrival of the Spanish came the fusion of Catholic attitudes and indigenous beliefs. The Day of the Dead or All Souls Day was revealed as a result of amalgamation of the pre-Spanish Indian ritual beliefs and the imposed ritual and dogma of the Catholic Church. Candles are often lit in ceremonies on the night of All Souls Day, as seen here at Mesa Grande. November 1 is the official All Saints Day, which honors all saints, followed on November 2 as All Soul's Day, honoring the faithful departed. (MOM.)

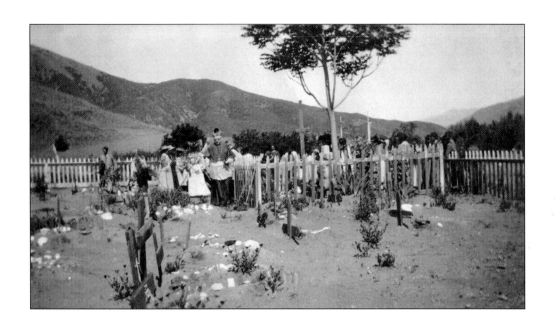

Above is the La Jolla cemetery between 1900 and 1920, and below is the Rincon cemetery during the same time period. Personal belongings are buried with the body, and in many instances, that still occurs today. The remainder of the belongings were usually burned. Mourning by the family usually lasts a full year; during that time, there is no participation in social functions. At the end of the year, a mourning feast is given and the family is then considered to be officially out of mourning. (Above, DB; below, MOM.)

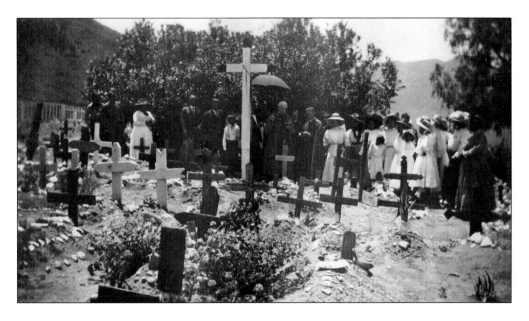

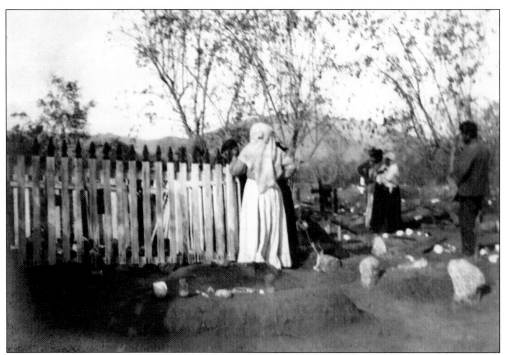

Above is the Pauma Cemetery shortly after the start of the 20th century; below is the new Barona cemetery around 1936 after the moving of the bodies from the Capitan Grande reservation for construction of the dam. At the burial of an Indian, there is singing and prayers are said in the form of a eulogy to the dead. There is no dancing, and the ceremony is usually carried out by the shaman or medicine man, who knows all the rituals. Today most Indian burials follow the Catholic religion as taught to them by the Spaniards. (Above, MOM; below, NARA.)

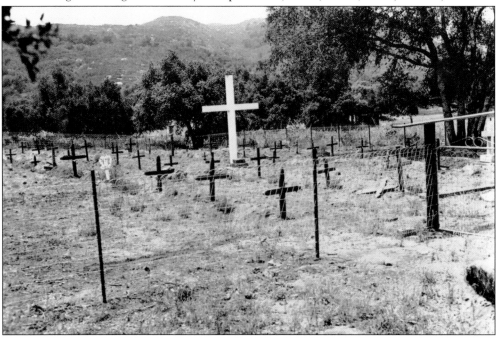

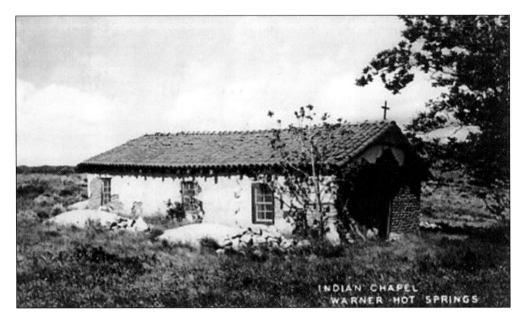

The Catholic chapel at Warner Springs, above, was originally built around 1830 and has since been renovated. Church functions and ceremonies are still held today for both Indians and non-Indians of the Catholic faith. Below is the dedication of the church at the La Jolla reservation after the beginning of the 20th century. Since the time of the Spanish conquest of California, Catholicism has been the predominant religion among the Indians. This church was burned during the Poomacha fire in October 2007 along with several of the homes on the La Jolla reservation. (Above, WHS; below, NARA.)

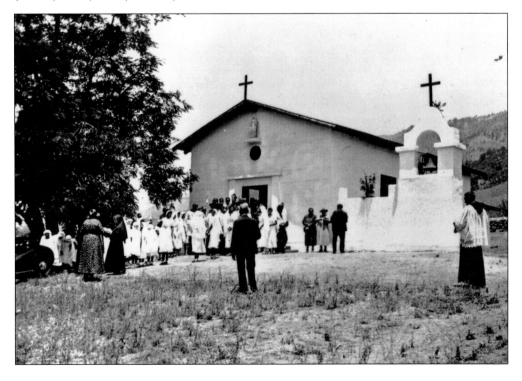

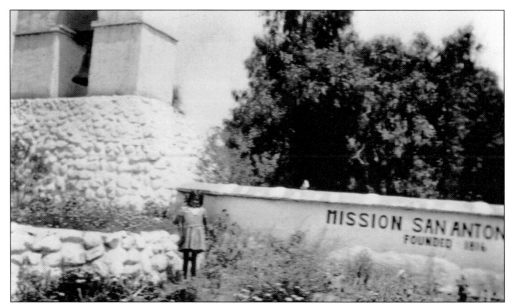

San Antonio de Pala was a sub-mission of Mission San Luis Rey de Francia. It was established in 1816 by Padre Antonio Peyri and is the only surviving *asistencia* in the California mission system as well as the only mission-related structure still ministering to an Indian population. The asistencia was named in honor of St. Anthony of Padua, who was nicknamed the "Wonderworker of the world." Pala continues to be an active Catholic church. Above is the base of the bell tower, and below, the church is shown about 1910 needing extensive restoration. (Above, NARA; below, MOM.)

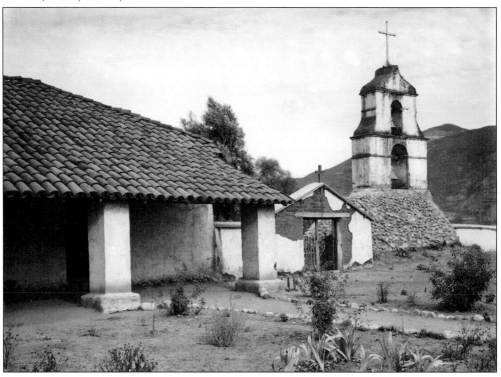

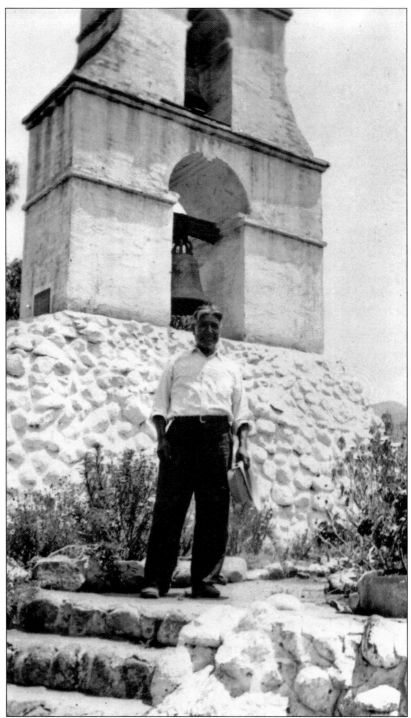

John Ortega stands in front of the bell tower of San Antonio de Pala in 1936 following the much-needed restoration of the asistencia. Inside the church, the original flooring and some beautiful Indian artwork can still be seen. The cemetery is located behind the bell tower and contains the remains of hundreds of Indian converts and early California settlers. It is still in use today. (NARA.)

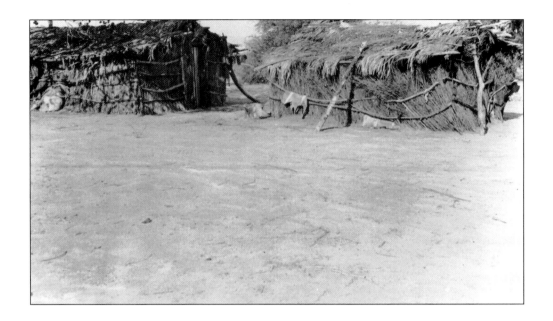

Living quarters for the Indians came in many various forms. Above is an old Indian home made of a thatched roof and walls held up by sticks. This type of home was no longer used after the dawn of the 20th century. Below is one of the old adobe homes with thatched roofs that were home to the Cupeño in their home village of Cupa. The homes at Cupa are now part of Warner Hot Springs, have been renovated and brought up to date, and are currently in use as part of the private resort. (Above, NARA; below, WHS.)

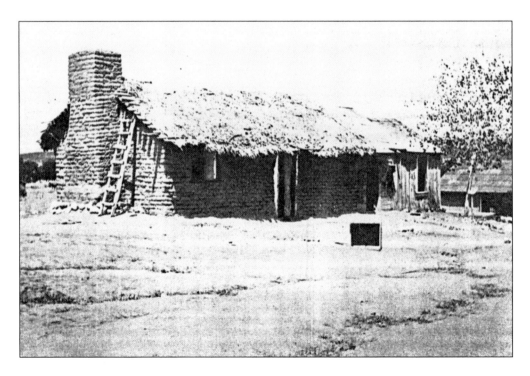

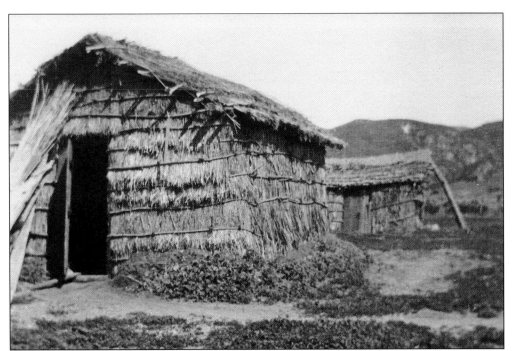

Above is one of the Indian homes at Potrero consisting of a thatched roof and thatched walls with reeds and sticks tied together. At right is the old John Cuero house located on the Manzanita reservation. It is constructed in the fashion of a ramada using brush, thatched roofs, and sticks, which is much more open and used primarily in warmer climates. This type of structure is much less permanent than the adobe or even the thatched homes such as the one seen above. (Above, MOM; right, NARA.)

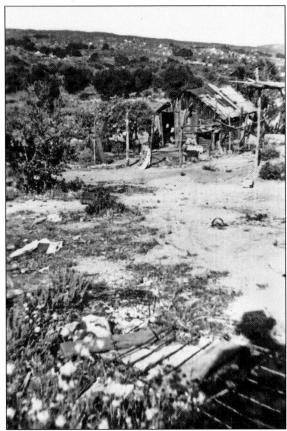

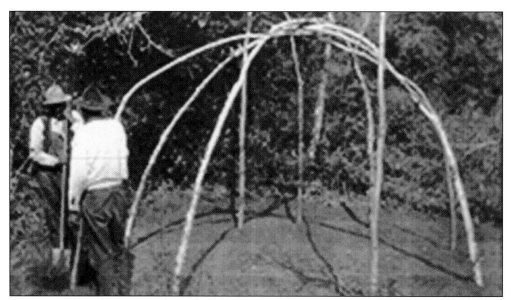

These next four photographs show the construction of a pre-contact Kumeyaay hut or 'ewaa, an ancient Indian shelter of the Kumeyaay Indians. Long thin sticks (above) are bent and buried into the ground in the shape of a dome for the initial framing of the hut construction. Below, grasses are used to thatch it, and additional sticks are tied with strong reeds or grasses to hold them in place. (Both, MOM.)

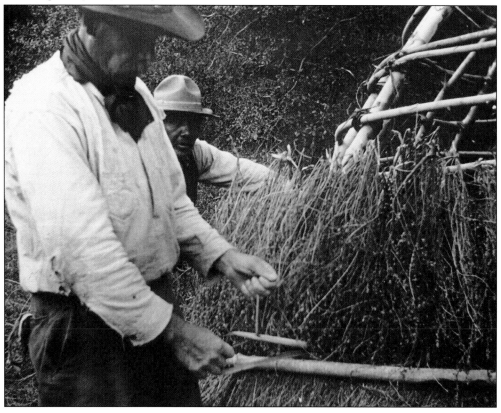

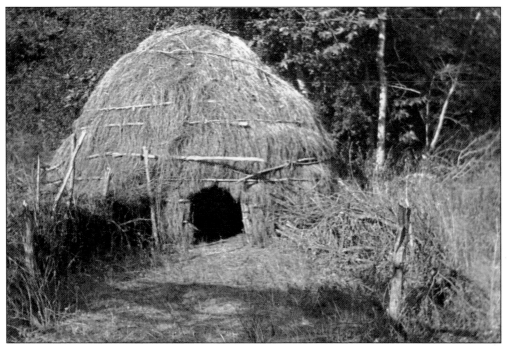

The hut is now complete and blends into the surrounding landscape. This particular hut was finished on Lee's Ranch in Dehesa on the Sycuan lands. Several of these in close proximity would make up a Kumeyaay village, which were usually of family groups and not very large or very numerous. Internally, these huts consisted of only one room (if a bathroom was needed, it was off to the bushes). (Above, DB; below, MOM.)

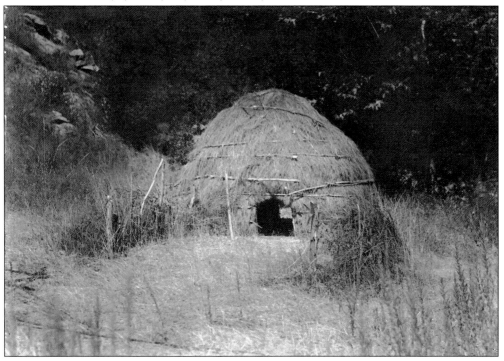

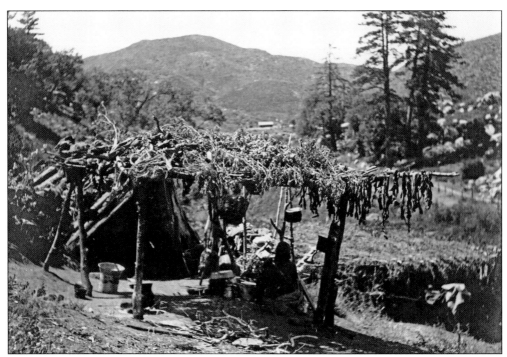

Above is a brush ramada–style house at Cuyapipe (Wee-a-pi-pa) from 1903. Note all of the buckets, ollas (Indian baskets), and pans hanging outside. Since the inside is primarily used for sleeping, most of the kitchen supplies were kept outside but up off the ground. Below is the actual home of "Aunt" Louisa Paipa of Alpine about 1910. This home is somewhat of an interim house between the ramadas, bush houses, and huts and the structured frame homes of today. As one can see, it has some of the qualities of all, but several of the household items are still kept outside. (Both, MOM.)

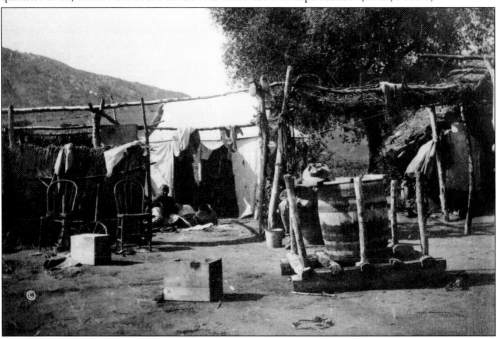

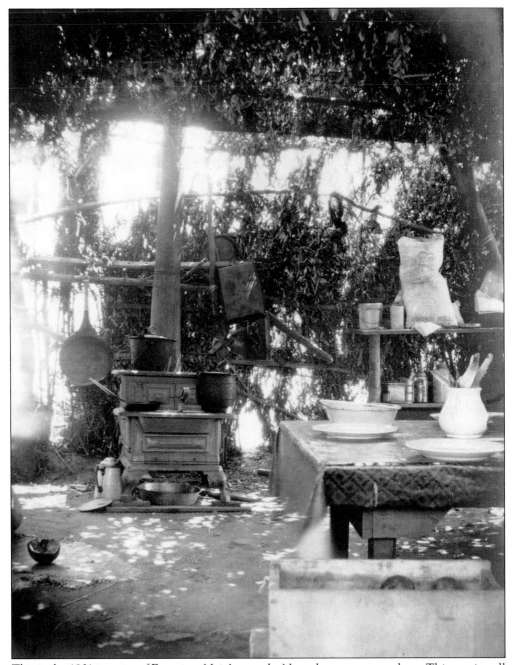

This is the 1901 interior of Francisco Nejo's ramada. Note the open atmosphere. This one is well furnished with a stove, table with tablecloth, and many household goods on the table, shelves, and floor. This is the cooking and eating area located at the front of the ramada. The back of the ramada was used for sleeping. (MOM.)

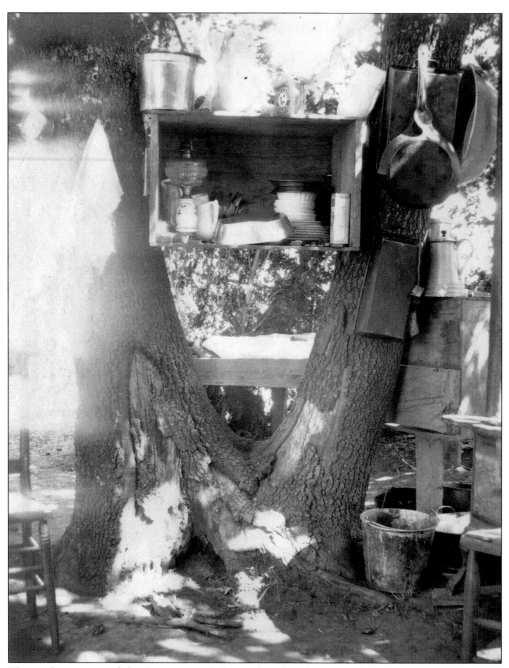

This is the interior of the Osuna ramada located at the Mesa Grande reservation around 1901. It was built around a tree with the kitchen at the fork of the tree and wooden boxes used as shelves for dishes, pots, pans, buckets, and chairs. The interior of each ramada was different and personalized much as modern homes are today, but they always blended in with the surroundings and left little or no damage to the countryside. (MOM.)

Three

A WORLD OF STRIFE

During the Spanish period in Southern California, and under the control of the mission system since 1769, Indians were treated as slaves. They were tortured into work and into converting to the Catholic religion. Their retaliations were unsuccessful. In 1821, when California came under Mexican rule, Indians were granted citizenship but were treated as peonage, often to the point of slavery or with the lower class working for the Mexican land holders. When the United States acquired California in 1847, the trifles of the past were to increase immensely.

Treaties were signed for land and rights but were not ratified by the U.S. Congress. They were placed under a veil of secrecy, and the Indians didn't know these treaties were invalid until 1905. When the Indians retaliated under Antonio Garra, a Cupeño Indian, they failed and Garra was executed. Epidemics from the Spanish and the Mexicans and later from the Americans settlers killed a large percentage of the Indian population.

From the 1850s to the 1870s, the white settlers engaged in genocide by the wholesale massacre of the Indians, condoned by the government, further reducing the Indian population to about 5 percent of its original number. Remaining Indians were enslaved, had their children and land removed, and were refused citizenship and the right to vote, let alone any form of medical care in a hospital. They were not even allowed to be a witness in a court of law.

In 1870, Pres. Ulysses S. Grant signed an executive order creating San Diego's first Indian reservations. He was soon to rescind that order and cause the Indians to be removed from the lands promised to them. Some Indians were not to receive designated lands until well into the 20th century. Indians were required to cut their hair short and cease performing their ceremonies and rituals, even on their own reservations.

Circumstances for the Indians would not begin to improve until 1924, when the Indians were finally granted citizenship and the right to vote, although not for local officials. Understanding their strife during this period helps to understand the rebuilding of their world.

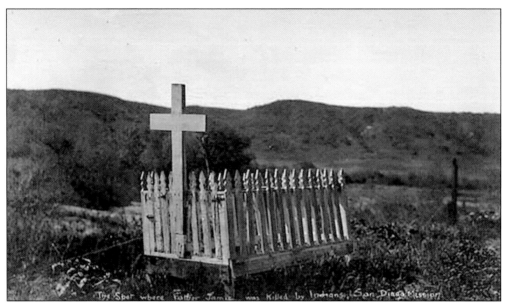

On November 4, 1775, approximately one month after completion of the San Diego Mission de Alcalá, the Indians attacked the mission in the middle of the night and burned it to the ground. The natives were driven by the torture and enslavement by the Spanish, which forced them to convert to the Catholic religion. During this raid, Fr. Luis Jayme was killed. Above is a marker signifying the place where he was killed. He is buried in the altar of the existing church. (DB.)

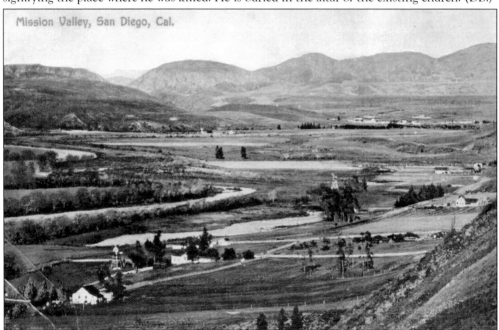

Before the present-day Mission Valley or Fashion Valley shopping malls were built, before Qualcomm stadium was built, and even before Interstate 8 was constructed and completed in 1958, Mission Valley was an Indian village with major Indian trails. This photograph depicts the serene surroundings and the peacefulness within the valley before all the construction took place and its transformation into the metropolis it is today. (DB.)

52

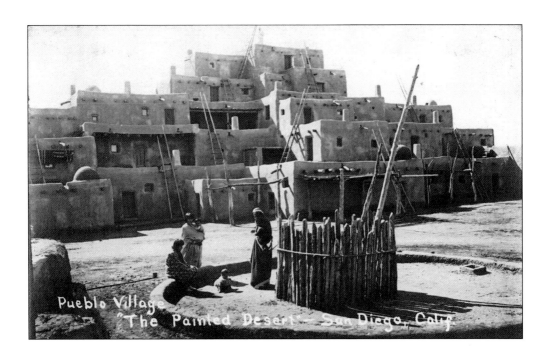

Pueblo Village "The Painted Desert"—San Diego, Calif.

During the Panama-California Exposition in 1915–1916, an Indian village was constructed to depict the life of the Indians. Unfortunately, nobody bothered to contact the local Indians to construct a village of the Southern California style. Instead, Indians of Arizona and New Mexico were contacted and built a village conducive to the natives of the Southwest that is nothing at all similar to the Indian housing and lifestyle of Southern California. (Both, DM.)

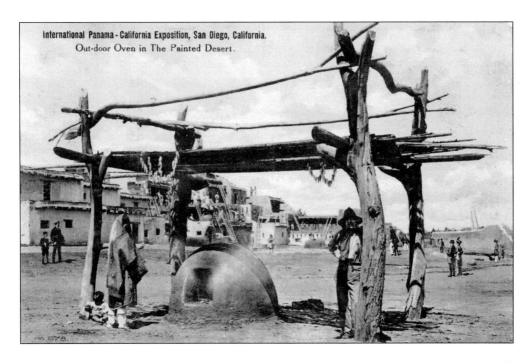

International Panama-California Exposition, San Diego, California. Out-door Oven in The Painted Desert.

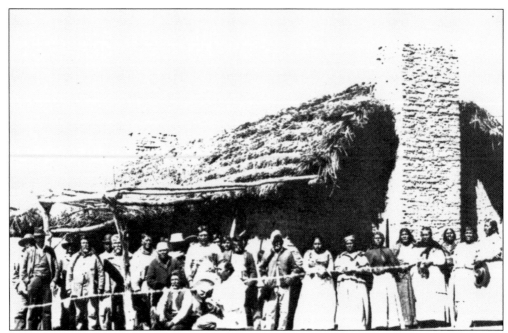

The Cupeño tribe lived for hundreds of years in the lands of their ancestors, a village called Cupa in what is known today as Warner Hot Springs. After the Warner Ranch title was transferred to John G. Downey, he wanted the Indians removed from his land. The Indians attempted to maintain their rights to the land and filed a claim in San Diego. This claim was lost, and the Indians then took it to the Supreme Court, where again they lost. On May 12, 1903, the Indians were forcibly removed from their ancestral lands by the Indian Bureau agent and 44 armed teamsters. Above is a council meeting before the eviction. Below is one of several photographs of the eviction from Cupa. (Both, WHS.)

Rosinda Nolasquez, the last survivor of the expulsion, later testified, "Many carts stood there by the doors. People came from La Mesa, from Santa Ysabel, from Wilakal, from San Ignacio to see their relatives. They cried a lot. And they just threw our belongings, our clothes, into carts." When the final decision of the *Barker v. Harvey* case was handed down and the eviction took place, it became known as the Cupa Trail of Tears. Many Cupeño believe that their land at Cupa will one day be returned to them, and they are actively seeking relief to that end. Here are two photographs of the eviction of the Indians. (Both, WHS.)

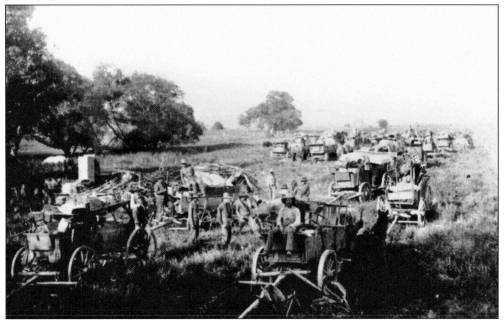

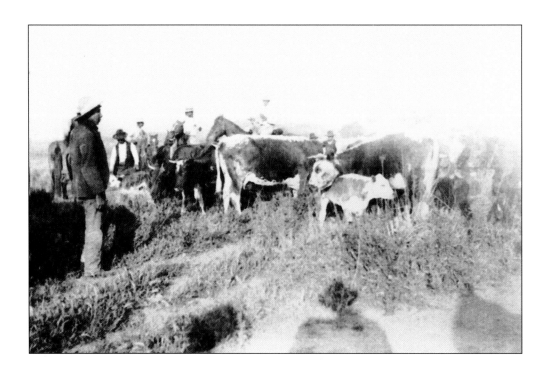

The U.S. government offered to buy new land for the Cupeños, but the Indians refused. In 1903, Cecilio Blacktook, Cupa chief at Agua Caliente (Cupa) said, "If you give us the best place in the world, it is not as good as this. This is our home. We cannot live anywhere else; we were born here, and our fathers are buried here." The Cupa site serves as a rallying point for the land movement of current-day Indian people, and the spirit of Cupa Village lives in Indian people's contemporary efforts to regain cultural and religious areas. The 40-mile trek took three days. Above is the herding of the cattle, and below is the first campsite for the first night. (Both, WHS.)

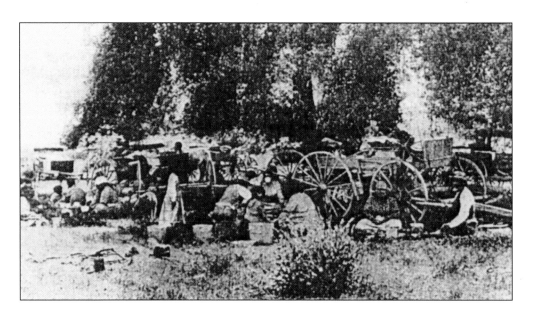

The Cupeños have since acquired a portion of the lands they lost during the eviction of 1903. Included with that land was the cemetery and burial grounds of the ancestors of the tribe. This is the plaque that now sits on a stone monument in front of that cemetery, which depicts the memories of the Indians. (DB.)

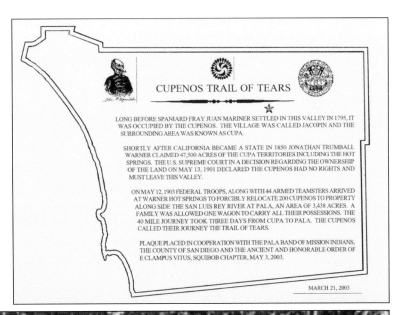

CUPENOS TRAIL OF TEARS

LONG BEFORE SPANIARD FRAY JUAN MARINER SETTLED IN THIS VALLEY IN 1795, IT WAS OCCUPIED BY THE CUPENOS. THE VILLAGE WAS CALLED JACOPIN AND THE SURROUNDING AREA WAS KNOWN AS CUPA.

SHORTLY AFTER CALIFORNIA BECAME A STATE IN 1850 JONATHAN TRUMBALL WARNER CLAIMED 47,500 ACRES OF THE CUPA TERRITORIES INCLUDING THE HOT SPRINGS. THE U.S. SUPREME COURT IN A DECISION REGARDING THE OWNERSHIP OF THE LAND ON MAY 13, 1901 DECLARED THE CUPENOS HAD NO RIGHTS AND MUST LEAVE THIS VALLEY.

ON MAY 12, 1903 FEDERAL TROOPS, ALONG WITH 44 ARMED TEAMSTERS ARRIVED AT WARNER HOT SPRINGS TO FORCIBLY RELOCATE 200 CUPENOS TO PROPERTY ALONG SIDE THE SAN LUIS REY RIVER AT PALA, AN AREA OF 3,438 ACRES. A FAMILY WAS ALLOWED ONE WAGON TO CARRY ALL THEIR POSSESSIONS. THE 40 MILE JOURNEY TOOK THREE DAYS FROM CUPA TO PALA. THE CUPENOS CALLED THEIR JOURNEY THE TRAIL OF TEARS.

PLAQUE PLACED IN COOPERATION WITH THE PALA BAND OF MISSION INDIANS, THE COUNTY OF SAN DIEGO AND THE ANCIENT AND HONORABLE ORDER OF E CLAMPUS VITUS, SQUIBOB CHAPTER, MAY 3, 2003.

MARCH 21, 2003

The Indians were forced to move to the Pala reservation on the San Luis Rey River. They were promised better housing and circumstances. This photograph shows one of the dilapidated homes they were expected to move into. Their belongings were dumped in front of two tents, and from there, they determined that these were the homes they were expected to live in. This was the first time in history that two completely different tribes were forced to live together. Cupeño Indians from the present day can be found on Los Coyotes, San Ygnacio, Santa Ysabel, and Mesa Grande reservations as well as Pala. (WHS.)

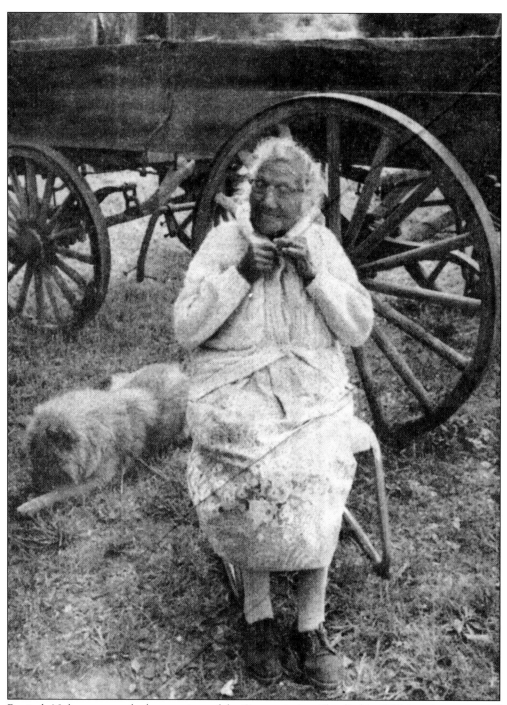

Rocinda Nolasquez was the last survivor of the Cupa eviction. She died in 1987, but the memory of the horror of what occurred will not go with her. This was one of the most publicized events that the Indians will not allow to be washed away and forgotten. Above is one of the final photographs of her taken for the newspaper when she presented her story and recollection. (WHS.)

Eviction left a trail of tears from village of Kupa to Pala

It was a warm spring morning and 11-year-old Rocinda Nolasquez was playing with her sisters and cousins in the green, rolling hills near the little village of Kupa.

Suddenly there was a terrible ruckus, Rocinda, now 93, recalled. Huge wooden wagons pulled by draft horses had rumbled through the dirt streets and past the neat adobe houses in the village, which stood at what is now the Warner Springs Ranch resort in northern San Diego County.

White men were shouting. Rocinda recalled, "I didn't speak any English then and I couldn't understand what they were saying."

What young Rocinda did not comprehend was that she and all her tribe were being sent on a journey that would end their ancient culture.

The small tribe, which never numbered more than 500, was being forced to abandon its ancestral village and move to a new reservation at Pala, 11 miles south of Temecula.

Rocinda Nolasquez is the last of the Cupeno Indians, who were evicted from Warner Springs on May 12, 1903.

All that remains of the Cupeno legacy are an old woman's memory, a nearly abandoned cemetery in Warner Springs and a few antique baskets and yellowed newspaper clippings on display at the Cupa Cultural Center at Pala.

The cultural center is some 50 road miles from Warner Springs. Among the displays is a picture of James E. Jenkins, the federal Indian agent in charge of the eviction.

It's been more than 82 years, but when Rocinda Nolasquez sees his turn-of-the-century photo she remembers the first time she saw Jenkins on the morning of eviction.

He had been standing by a big wagon, snapping a rope as if it were a whip while he barked orders that sounded like gibberish to Indian children, Rocinda said.

"We were so scared. We didn't know what he was saying," she said. "We didn't know what was going on. We saw old people crying and running back and forth. We cried, too, because we were afraid."

Rocinda said she and the rest of the villagers were hurried onto the wagons. "We had to leave our chickens and turkeys and dogs," Rocinda said. "All I could take were my two cats. My sister's cow had a calf, and

(See ROCINDA, Page B-4A)

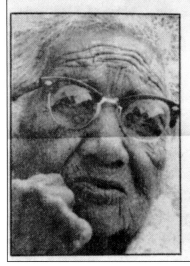

'They told us we were going to come to our new homes, nice two-story buildings. When we got here, there was no home.'

Rocinda Nolasquez

Above is one of the newspaper articles from one of the final interviews with Rocinda Nolasquez in regards to the Cupa eviction. With the help of the Luiseño Indians, attempts are being made to reacquire the lands where once stood their beloved village of Cupa. (WHS.)

Above and below are scenes from Capitan Grande reservation from 1936. In 1932, Congress, at the desire of land speculators and unbeknownst to the Indians, granted the City of San Diego permission to purchase the heart of the Capitan Grande reservation, upon which many Kumeyaay families had built their homes. The people were forced off their ancestral lands on the San Diego River in order for the city to build the El Capitan Dam and reservoir. The Indians who once resided on this vacated reservation now inhabit the Barona and Viejas reservations. Not only were the families relocated, but the cemetery with their ancestors was relocated as its original location is now underwater. (Both, NARA.)

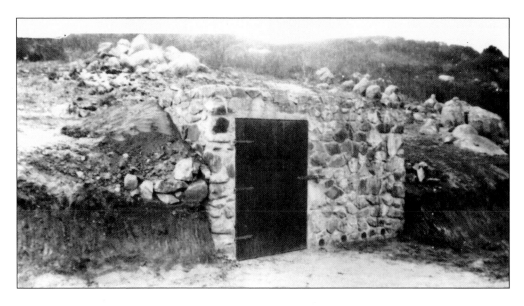

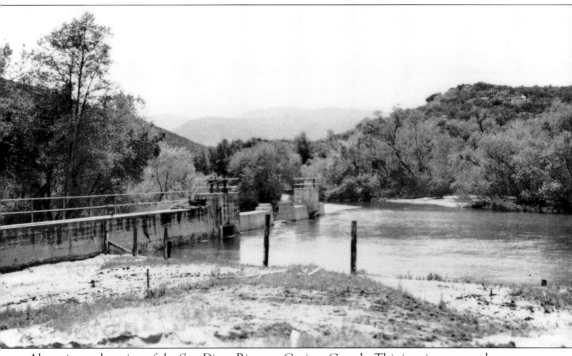

Above is another view of the San Diego River on Capitan Grande. This is a site never to be seen again as it is underwater. Indians have been perpetually relocated at the convenience and whim of the white man. Now, with reservations finally legally in place, hopefully this will be a thing of the past. Now the Indians who have lived here in excess of 10,000 years have a piece of paper stating that the land is theirs, something they have lacked in the past. (NARA.)

"In the month of October last I apprehended three kidnappers, ... who had nine Indian children, from three to ten years of age, One of the three was discharged on a writ of habeas corpus, upon The testimony of the other two, who stated that 'he was not Interested in the matter of taking the children:' after his discharge The two made an effort to get clear by introducing the third one as a witness, who testified that 'it was an act of charity on the part of the two to hunt up the children and then provide homes for them, because their parents had been killed, and the children would have perished with hunger.' My counsel inquired how he knew the parents had been killed? 'Because,' he said. 'I killed some of them myself'."

J. Ross Brown re: Indian conditions in Southern California

Did Indian slavery exist in California prior to 1850? Yes, it did, although differing from slavery in the South prior to the Civil War. Native Indian populations were bound to their Spanish and Anglo-American masters through a set of laws that culminated in the so-called Act for the Government and Protection of Indians of 1850.

The Reporter, Vacaville, California

All Indians must be required to obtain service, and not be permitted to wander about the country in idle and dissolute manner; if found doing so they will be liable to arrest and punishment by labor on the Public Works at the direction of the Magistrate.

Given at head quarters in Yerba Buena **September 15, 1846.**

JOHN B. MONTGOMERY. **Commanding District of San Francisco.**

Published for the government of all concerned.

Washington A. Bartlett **Chief Magistrate.**

Above are quotes from various resources referring to the Indian slavery in California. The Act for Government and Protection for Indians of 1850 was commonly referred to as the California Indian Slave Act. If an Indian was unemployed by the white man, he was arrested for vagrancy and fined. Since he could not pay for the fine, he was sold to slavery until at least double his fine had been paid. Children were taken from the Indians and turned into slaves. A female child could be forced to work until age 25 and a male until 30 years of age. This was all condoned by the state government. (DB.)

"We hope the Government will render such aid as will enable the citizens ... to carry on a war of extermination until the last redskin of these tribes has been killed. Extermination is no longer a question of time – the time has arrived, the work has commenced, and let the first man that says treaty or peace be regarded as a traitor."

**Yreka Herald
1853**

**U. S. Senate
Debate
26 May 1860
Read by
Secretary
from article
in Alta
Californian
published in
San Francisco**

"The attacking party rushed upon them, blowing out their brains, and splitting open their skulls with tomahawks. Little children in baskets, and even babes, had their heads smashed to pieces or cut open. Mothers and infants shared the common fate. The screams and cries of the victims were frightful to hear, but no supplications could avail to avert the work of devilish butchery. It will scarcely be credited that this horrible scene occurred in Christian California, within a few days' travel of the State capital. Humanity sickens at the thought. Many of the fugitives were chased and shot as they ran. Where Whole families had been butchered was indicated by heaps of bodies composed of the mother and her little ones. The children, scarcely able to run, toddled towards the squaws for protection, crying with fright, but were overtaken, slaughtered like wild animals, and thrown into piles. From under some haycocks, where some of them had taken refuge, they were dragged out and slain. One woman got into a pond hole, where she hid herself under the grass, with her head above water, and concealed her papoose on the bank in a basket. She was discovered, her head blown to pieces, the muzzle of the gun being placed against her skull, and the child was drowned in the pond. The ground was covered with blood, and the brushwood ranches, of which there were fifty or sixty, were filled with the dead bodies. Old decrepit squaws, young girls, and infants, none were spared. Guns, knives, and hatchets were used, but the favorite method appears to have been staving in the head with tomahawks. The blush of dawn shown upon this fearful spectacle, and still the massacre went on."

"That a war of extermination will continue to be waged between the races, until the Indian race becomes extinct..." **Peter H. Burnett – 1851
Address to the legislature.**

Genocide was perpetrated against the Indians. And what makes this disturbing is that it was subsidized by both the state and federal governments. In 1851 and 1852, the California Legislature passed several acts authorizing payment of over $1.1 million to reimburse citizens for "private military forays." In 1857, the state authorized an additional $410,000 for the same purposes. And the U.S. Congress reimbursed the state for what was nothing less than subsidized murder and genocide. Note also that scalping was not practiced by the Indians of San Diego County prior to European contact. Scalp bounties were paid by the state to those who killed the Indians. This was a practice introduced to the Indians by the white man. (DB.)

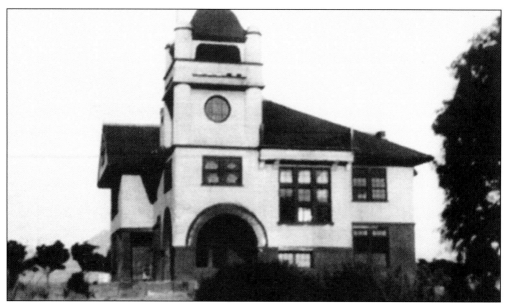

Above is the Sherman Indian School located in Perris, California, in Riverside County. Many of the children of Indians of San Diego were taken here if their parents were killed or if the white man just decided to remove the children. This was a boarding school, and during the time the children were here, they were not allowed any of their customs or rites. They were denied access to family to reduce the Indian influence. They were not allowed to speak their native tongue and were forced to cut their hair to make them look and act less Indian. When an Indian took in an orphaned white child, the child was raised as family and treated accordingly. Below are Guadalupe Alto Martinez (second from left), Jose Juan Martinez (third from left), and Jack Martinez (back right) from San Pasqual with a neighbor (far left) and an unidentified white boy they had taken in (far right). Note that he is treated just like one of the family. (Above, DB; below, DMT.)

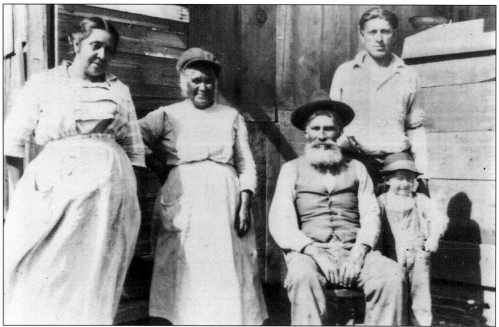

When schools were finally built on the reservations, white teachers taught white customs and language. At right in 1908 is a teacher with student George Paul Martinez at the age of 12 from San Pasqual. These teachers were instructed to make a white man out of the Indian. Their job was not only to teach English (which few of the Indians spoke or understood) but to "humanize the savages." Below are the students from the Mesa Grand school in 1891. (Above, DMT; below, MOM.)

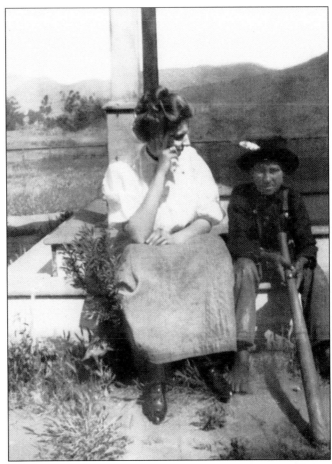

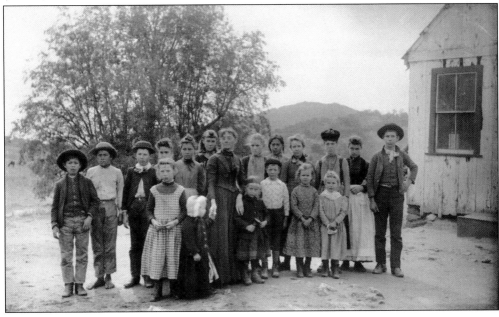

Above are the school and the playground at the Rincon reservation, and below is the Indian schoolhouse at Warner Springs Ranch. The Indians were perfectly capable of teaching their children the basics needed for everyday life, but they did not teach the white man's customs, math, or the other courses they saw no need for. They taught survival skills learned from the many years of conflict and strife they had suffered. They taught their children how to stay alive. (Above, NARA; below, WHS.)

"The first 50 years of the American Period was a horrible time for the Native Californians, given the sheer magnitude of what happened during that half century: scalpings of men, women,, & children; incarceration in jails with the only way out being enforced indenture to whites for unspecified lengths of time; the kidnapping & sale of Indian children; the massacres of entire Indian villages; the military roundup of Indians and their enforced exile on military reservations where even the most basic of living amenities were lacking; their complete legal disenfranchisement. The outcome of all this was that during the first two decades of the American occupation, the native population of California plummeted by 90 percent – in short, a California version of the WWII Holocaust."

**C. R. Smith
Instructor of
Anthropology
Cabrillo
College**

"The whites attacked and the bullets were everywhere. Over four hundred and fifty of our people were murdered or lay dying on the ground. Then the whitemen built a huge fire and threw in our sacred ceremonial dresses, the regalia, and our feathers, and the flames grew higher. Then they threw in the babies, many of them were still alive. Some tied weights around the necks of the dead and threw them into the nearby water.
Two men escaped, they had been in the Sacred Sweathouse and crept down to the water's edge and hid under the Lily Pads, breathing through the reeds. The next morning they found the water read with blood of their people."
An Indian man tells the story, years later.

"The destruction of the Indians of the Americas was, far and away, the most massive act of genocide in the history of the world." **David E. Stannard**

"By then (1891) the native population had been reduced to 2/5% of its original numbers and 97.5% of the aboriginal land base had been expropriatedHundreds upon hundreds of native tribes with unique languages, learning, customs, and cultures had simply been erased from the face of the earth, most often without even the pretense of justice or law." **Peter Montague**

"The inhabitants of Los Angeles are a moral and intelligent people and many of them disapprove of the custom [if auctioning off prisoners] on principle, and hope that it will be abolished as soon as the Indians are all killed off." **J. Ross Browne**

The Indians of San Diego County have survived much: from murder, kidnapping, slavery, and theft of their ancestral lands to genocide in an attempt to totally abolish the Indian race. The U.S. government had endorsed these actions, and yet the Indians remain a proud and productive people. They have managed to survive countless bitter conflicts and still make the necessary adjustments to continue their heritage. (DB.)

Indian health provisions were something else that was deprived from the natives. Above is the home where a field nurse came to visit a woman with an illness. When the Europeans first arrived in California in the mid-1500s, they brought in many diseases the Indians had never been exposed to; therefore, their bodies were unable to fight off the illnesses. Unfortunately, their medicine men and women were not able to treat a disease they had never dealt with before. By 1900, (below) Indians had built health centers because they were still often refused medical care in hospitals. That privilege was not granted to the Indian until after they acquired their citizenship in 1924. Even pregnant women could not deliver their babies in the sterile atmosphere of a medical care facility until after that time. (Above, NARA; below, WHS.)

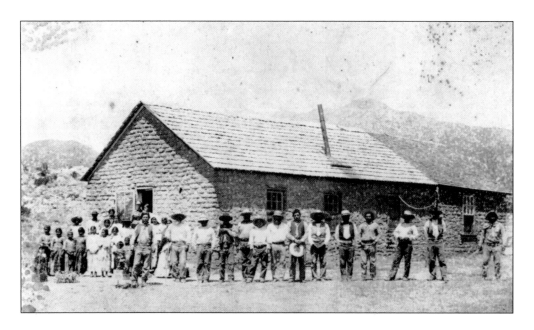

Four

THE REBUILDING

Ulysses S. Grant designated lands to the Indians in 1870 and then rescinded that executive order in 1875, which had granted lands to the Luiseño and Kumeyaay, forcing them to either move or be removed from what they thought were their home reservations. The Cupeños were evicted off their ancestral homes after losing a court battle showing that they had been on the lands for centuries. Congress sold the Capitan Grande reservation, where the Indians had been living for years, to the City of San Diego to build a dam; the Indians were forced to move to what is known today as Barona and Viejas reservations. All these events occurred and much more, forcing the Indians to rebuild their homes and villages.

Rebuilding meant more than just moving; they had to literally rebuild their communities. They had to make roads, reinforce embankments, build bridges, locate and set up a water supply, and fence pastures for their animals, all this before they could start rebuilding their homes. During that time, they had to make do with the available housing, sometimes accumulating several families into one structure, which could be a single-room hut or some other type of existing structure. They had to build travois to carry their personal property or pick up their belongings that had been dumped on the ground by whoever had transported them; and these had to be incorporated in what would eventually be their new home or village. They had to re-plow their fields to supply foods to their families and animals. And while they were doing all this, they had to attempt to make a living so supplies could be acquired for all of the reconstruction materials.

Many worked hard and yet remained virtually penniless, but thankfully had a roof over their heads. And in addition, many had to rebuild their self image and psychological state in order to feel they had a purpose.

They did this and much more over the next several years as they attempted to rebuild their lives, mental states, and self-respect.

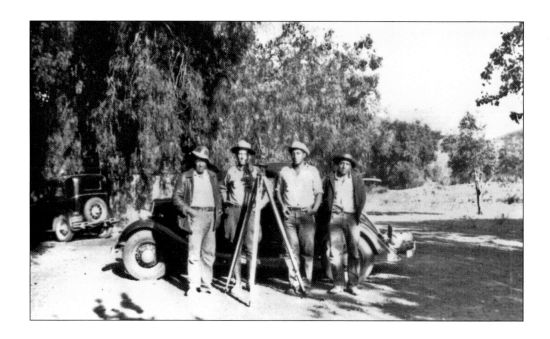

In 1870, Pres. Ulysses S. Grant signed an executive order approving 92,000 acres of land for the San Pascual reservation from Ramona to Mount Woodson and Highland Valley to Lake Wolford. He rescinded that order five years later. In 1901, the Indians were evicted off their lands when the U.S. Supreme Court failed to uphold the Indian land rights treaties established with the Mexican government. In 1903, the government purchased a much smaller piece of land and moved some of the Kumeyaay there. Above, listed in no particular order, is the boundary survey team including William Coleman, C. Anderson, Jack Guassac, and Gado Guassac surveying San Pascual. Below is the survey team for the La Jolla reservation. (Both, NARA.)

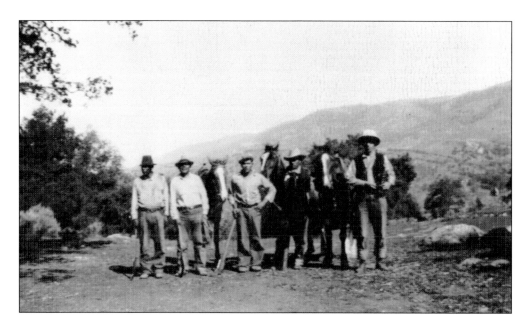

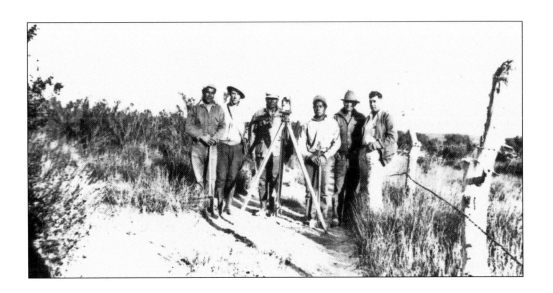

All of the reservations had to be surveyed to determine their borders, though the Indians at one time did not understand the necessity of boundaries. Above, listed in no particular order, is the survey team for Campo consisting of C. Anderson, Aguano Chappo, Augustine Lachapppa, Ramon Pinto, and Marcos Golsha. The Indians were perpetually moved farther and farther back onto rocky lands and hills with severe slopes, which made it extremely difficult to build upon, let alone useful for any type of agricultural fields for farming. Below Frank Hamilton and John Elliott are cutting back slopes on the Manzanita reservation in order to make usable lands. (Both, NARA.)

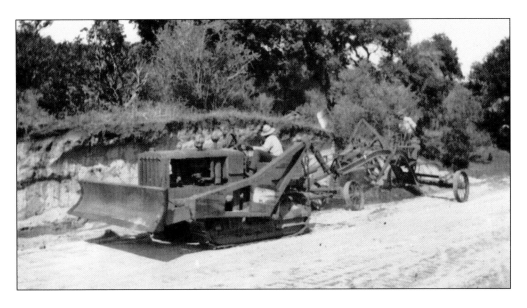

Once the lands were surveyed, the boundaries had to be fenced. Using available trees, fence posts were cut and allowed to season for the fencing process. Above is a stack of wood posts seasoning for the boundaries of the Pala reservation, and at left, in 1936, are cedar posts seasoning for the fence post project at Santa Ysabel. (Both, NARA.)

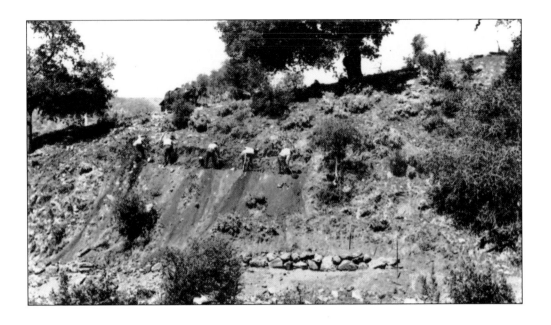

After hillsides were cut back, retaining walls were built from rocks collected for this purpose. Above is the side of a hill cut at Santa Ysabel and the beginning of the collection of rocks for the start of a dry masonry retaining wall. Below, also at Santa Ysabel, is the snaking of stone for another dry rubble retaining wall. No concrete or cement was used in these walls. Support was based on the thickness of the walls and the proper fitting together of the stones. (Both, NARA.)

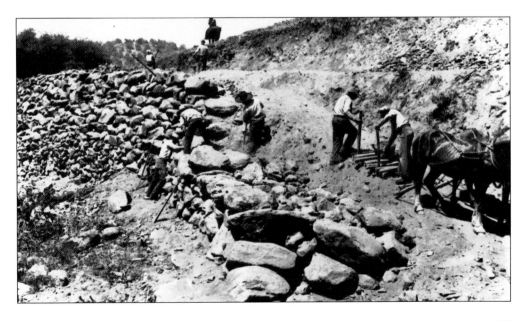

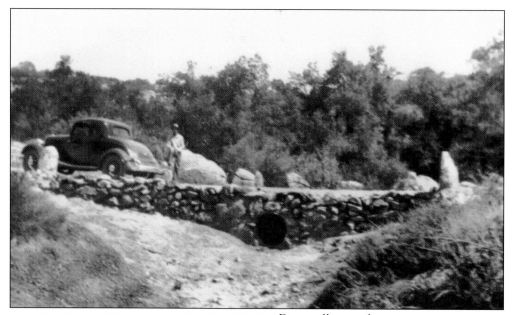

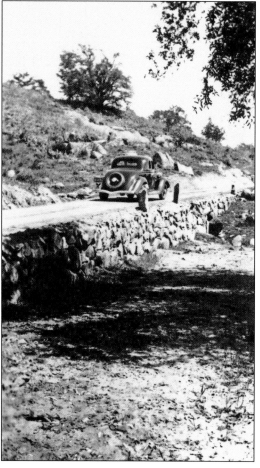

Deep gullies on the properties were breached so roads could be built. Above is a retaining wall with a culvert to direct water flow during the winter months on the Campo reservation lands. At left, Mesa Grande reservation also has to build retaining walls with culverts for their roads. With most Indian reservations located in such hilly terrain, all were working on these walls and inserting culverts so as not to interrupt the natural water flow. (Both, NARA.)

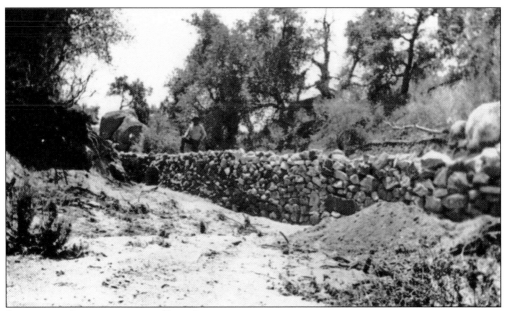

Sometimes these retaining walls and culverts had to be built over wide areas where water could potentially flow. The residents had to consider heavy rains and potential flooding. Above is a long retaining wall over what could potentially be a creek bed at Campo. Sometimes these retaining walls were built over steeper and deeper areas, as seen on this truck trail at Santa Ysabel at right. When more water was a possibility, culverts were spanned with wooden posts for support as shown here. (Both, NARA.)

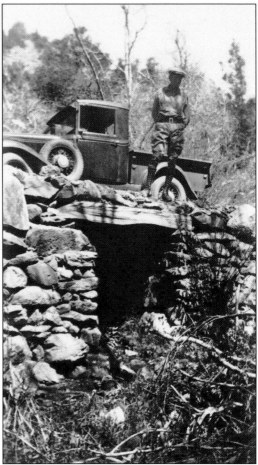

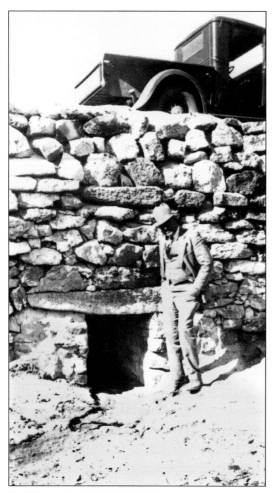

Taller retaining walls were built in several deeper gullies, such as the one at left at Manzanita, which compared to the height of a man and was strong enough to bear the weight of vehicles for the truck trails. Culverts built higher up on the walls allowed for pooling of waters for stock ponds, but also still allowed for the flow of water, as seen with this culvert built higher up on the retaining wall at Santa Ysabel below. (Both, NARA.)

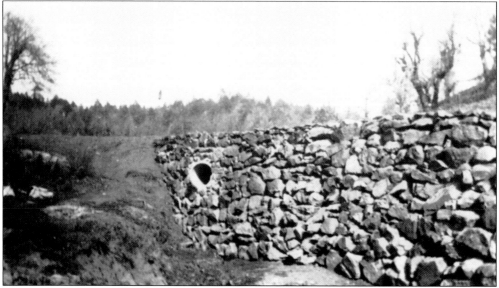

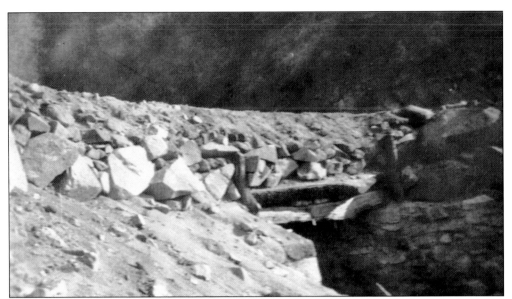

This very steep gully (above) between two hillsides is a culvert built on a truck trail at Sycuan. Because of the hilly landscape, truck trails, which curved through the mountains and trees, were used for roads. Note the lack of guard rails (right) at the time on the truck trail in Santa Ysabel in the pines. (Both, NARA.)

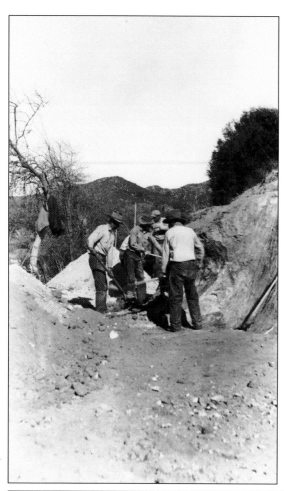

Volcan, a portion of Santa Ysabel, can be seen at left developing additional roads for vehicles to travel upon the reservation. Not only did the roads have to be cleared and graded, but consideration had to be made for rock slides in bad weather. Below, a truck trail is being constructed on Rincon. Once the road is graded, it is determined that a retaining wall must be built on the hillside and stones are accumulated for a rock wall there. (Both, NARA.)

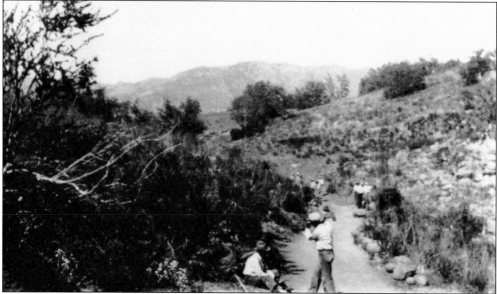

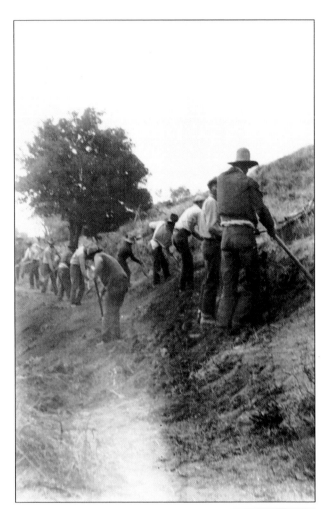

Much of the roadwork is done, not with heavy equipment, but with the back-breaking labor of men using shovels. At right, on Volcan, dirt is moved to widen an area for a truck trail. Below, on Pauma, rock is cleared and dirt smoothed for a truck trail. No heavy equipment is seen here either, just a lot of Indian workers and shovels. (Both, NARA.)

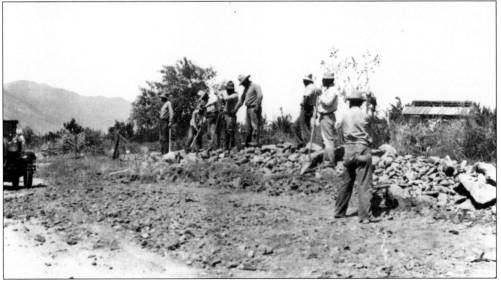

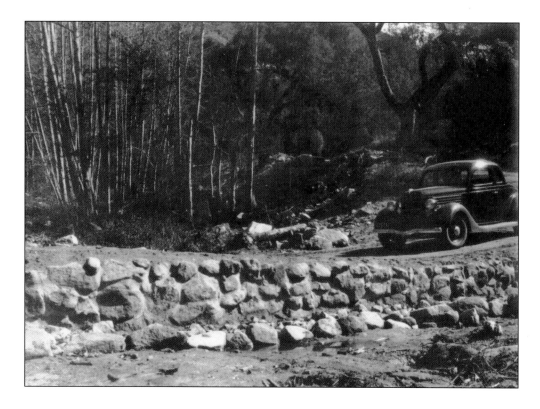

A dip at Pachatic Creek on Pala required a culvert and a retaining wall for the truck trail above. Also at Pala is the Palomar truck trail, which had to be cleared and leveled; below, readers can see the accumulation of rock for a retaining wall built to prevent rock fall from the hillside. Roads were built not only for ingress and egress to the reservations, but also within the reservations for access to potential home sites and community buildings. (Both, NARA.)

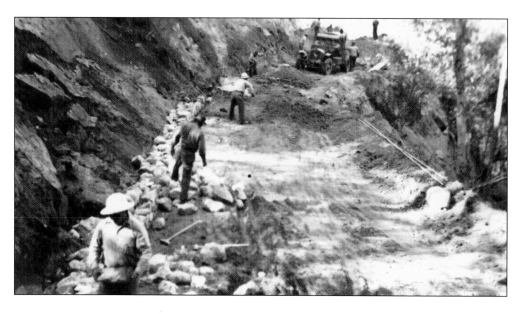

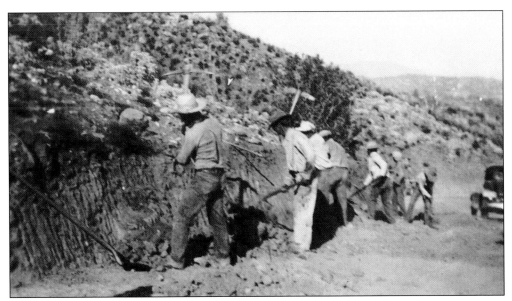

When the ground was harder and more compacted, picks were used to break it up so it could be leveled for vehicles to pass on the roads, seen above. Indians at Pala spent much time working on their roads, leveling them by transferring dirt to make roads smooth. At right is a completed smooth dirt road with a bridge and guard rails made of wood over the bridge. This is the Saasu truck trail on the Pala reservation in the 1930s. (Both, NARA.)

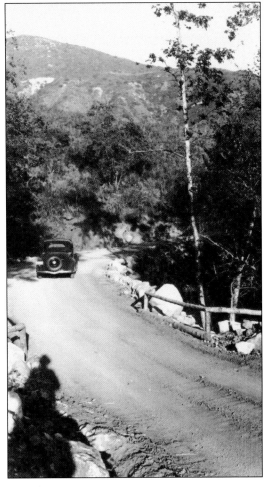

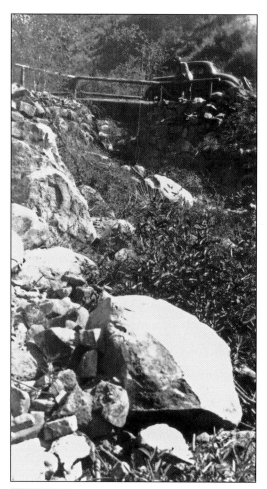

Some suspension-type bridges were built over creeks and ravines. These usually had wooden guardrails built across them to help prevent driving off the bridges. At left, on Pala, is one such bridge built on one of the truck trails. Below, at Potrero, land is cleared in a relatively flat area for a truck trail. Note that these were not referred to as roads since there was no paving like that seen on roads today. These were dirt roads built for access purposes only. (Both, NARA.)

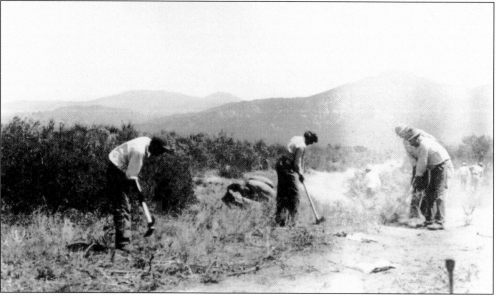

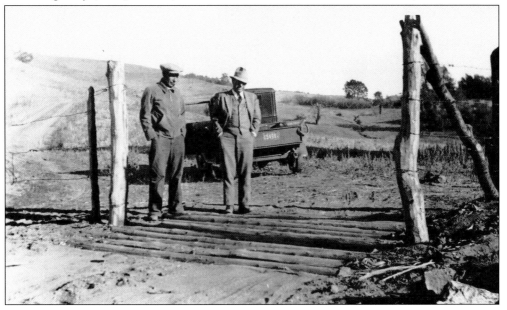

After a culvert was built on a truck trail, dirt had to be placed over the culvert, which could make for a smooth road. At right, Indians at Santa Ysabel are covering the top of the culvert with dirt to level it for an easier ride. Below, from left to right are Winslow Couro, an Indian leader, and Henry Reiger, project manager, overlooking a cattle guard to be placed near an entrance to the area at Volcan. These were built into the roads to prevent cattle from wandering away. (Both, NARA.)

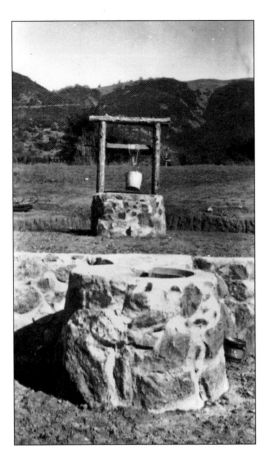

Water was very important on the Indian reservations as it was not only needed for human uses like bathing, laundry, and consumption, but also for the care of their herds of animals. At left is a well and stock trough at the Santa Ysabel reservation in 1936. Here a mortar is used with the rock since water is not meant to penetrate or flow through as it is on the culverts of the truck trails. Below is a spring-fed stock trough at Los Coyotes. (Both, NARA.)

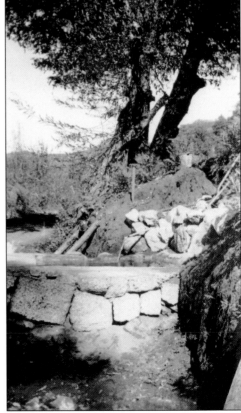

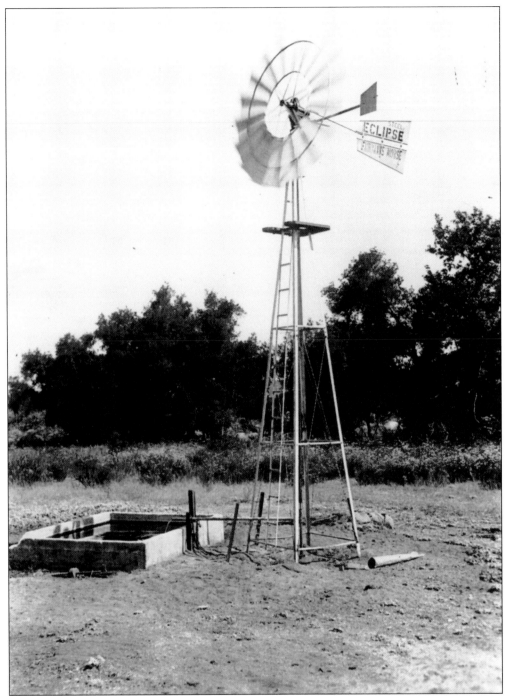

Indians at the Barona and Viejas reservations purchased their lands when removed from Capitan Grande in the mid-1930s. As a result, they have much more open pasture lands, which act as wind tunnels. Therefore, as seen here on Barona in 1936, windmills supply much of the water that is pumped up from the ground for cattle herd usage. (NARA.)

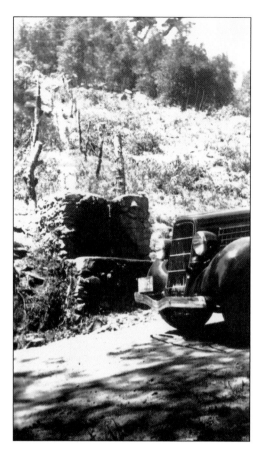

Since the Indians lived in areas with much brush and trees, water was also used in the consideration of fire. Often, when wells were dug for stock water, close by would be a water supply for fire control. At left and below are stock troughs and fire water tanks close together at Santa Ysabel. Several of these were built near roadways or truck trails for easier access. The aboveground portions were made with a mortar and stone to prevent leakage of the water out onto the roadway during seasons with a higher water table. Prior to the influence of the white man, Indians used fire as a tool to manage plant and wildlife populations. They did not need the fire tanks or stock water since they did not enclose their animals and often had controlled burns. (Both, NARA.)

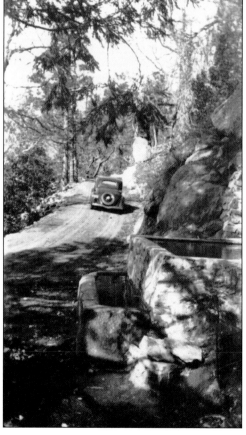

It was okay to acquire water from springs for stock water and fire tanks. At right, on Santa Ysabel, this 750-gallon tank of water could be used for both. Below, also at Santa Ysabel, is a dual-level combination stock and fire tank built for readily available water usage. The natives were skilled in using fire for the protection or conservation of structures, flushing wildlife for hunting, and managing vegetation to keep grazing animals close at hand. Prior to the curtailing of native burning, the large destructive fires of today were not as commonplace. Natives had a very strong understanding of controlled burning to manage plants, discouraging the growth of unwanted plants and encouraging the plants they desired, such as those used in basket weaving. (Both, NARA.)

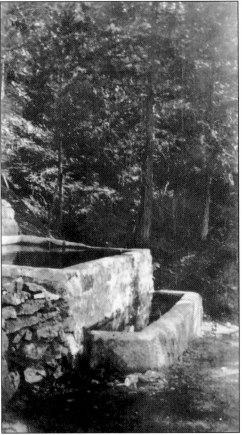

This firebreak at San Pascual is similar to several on Indian reservations throughout San Diego County. Indians would also use fire to improve growth of specific plants by eliminating the unwanted vegetation. The brushy undergrowth of trees was controlled with fire, and the smoke was used to collect honey from beehives. Fires were used to roast insects to be eaten, such as grasshoppers and crickets, and it could also drive out the unwanted rodents. (NARA.)

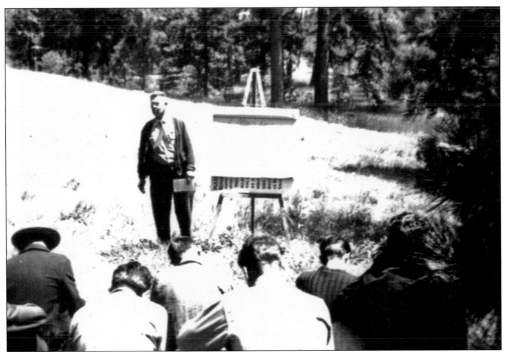

Fire helped to divert wild game, such as deer, to smaller uncleared areas, making them easier to hunt. When weeds grew around their homes, Indians cleared them with small controlled fires. Indians were eventually denied the right to their controlled burns as the white man feared and did not understand the Indian control of fire. Above, a U.S. Forest Service instructor is giving the Indians guidance on fire control. Below is one of the older fire trucks owned by the forestry department in the mid-1930s. (Both, NARA.)

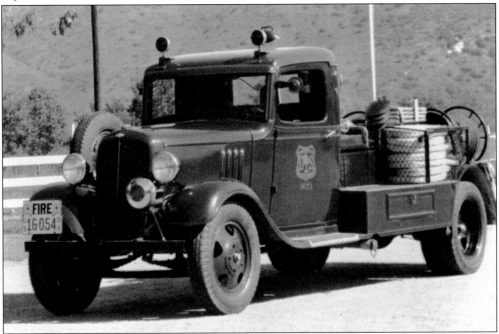

These cattle are drinking from a small reservoir of water at the Santa Ysabel reservation, located at the base of Volcan Mountain. Range cattle have an instinct and can actually smell when water is near. (NARA.)

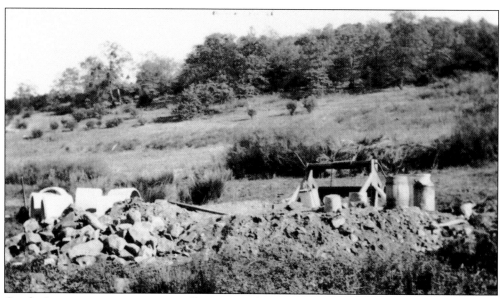

On the Inaja reservation, a water well system is also in place for their stock. (NARA.)

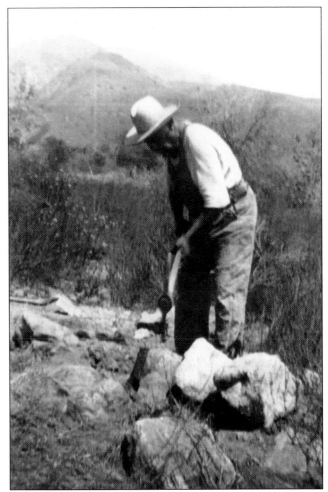

Erosion control was required to curtail damages caused by flowing water. Rocks were broken up and stacked to slow down the water and minimize contact with the soil, thereby preventing erosion on the banks. At right, on the Pauma reservation, an Indian breaks up larger rocks to use for the construction of an erosion control dam. Below is a completed erosion control dam in Arroyo on the Pauma reservation. (Both, NARA.)

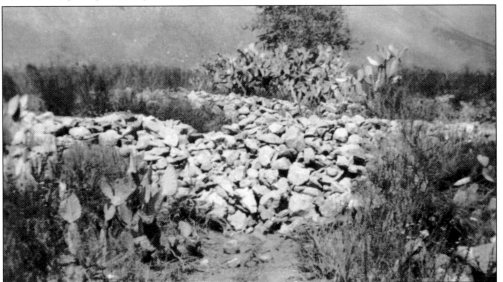

On larger rivers, embankments were protected against erosion with sticks or branches, which caused the waters to strike against them and slow down before hitting the soil on the river's edge. This was primarily used over longer areas of the embankment. This method is being used here at the Rincon reservation. (NARA.)

Diversion dams were used to control the direction of the water flow as seen here in 1934 at the Pala reservation. Diversion dams were used to direct water to fields for irrigation and away from areas where homes were built or going to be built. (NARA.)

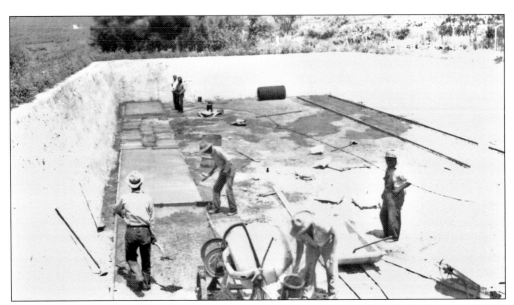

To conserve water, a 24,000-gallon reservoir was built on the Pauma reservation. Since water was such a valuable commodity, conservation was necessary. With the populations in the cities growing so rapidly, what water could be protected had to be. (NARA.)

The Escondido Water Company built ditches across the San Pascual reservation to divert large quantities of water to the cities for use. This is Ditch Three of those ditches, built in the 1930s. (NARA.)

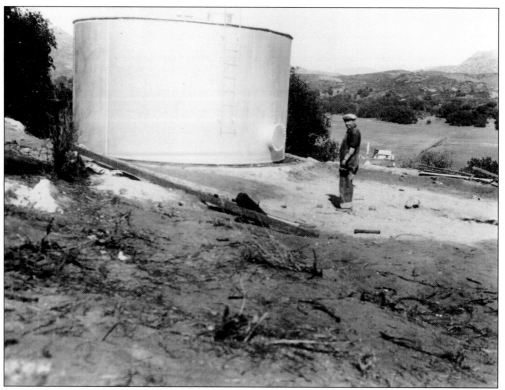

In 1936, the Barona reservation set up this steel storage tank for domestic water usage on their reservation. Large water storage tanks such as this are commonplace today for domestic water storage both in the urban areas as well as the rural areas of San Diego County. (NARA.)

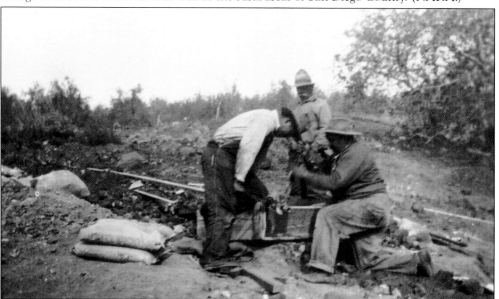

At the Mesa Grande reservation, fitting pipe to direct water in connection with spring development was needed to divert water to a required area. This type of more modern diversion began in the 1930s on some of the reservations and is more of what is in use today. (NARA.)

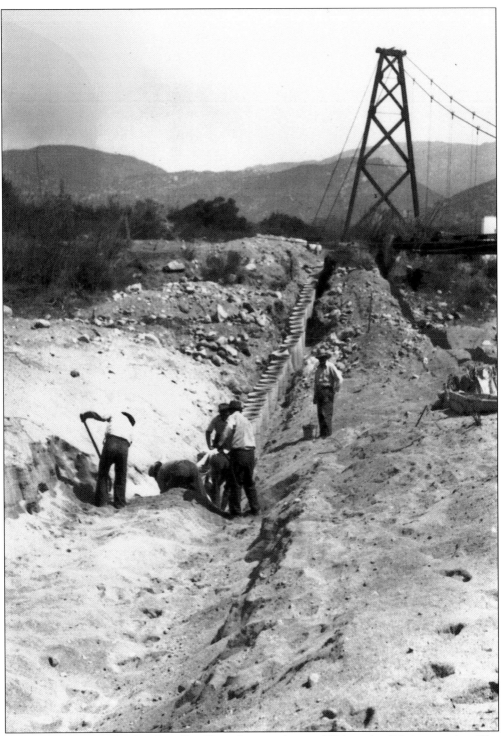

Men lay pipe across the San Luis Rey River here in August 1934 on the Pala reservation. The San Luis Rey and San Diego Rivers were the primary water sources for the Indians living on the inland territories of San Diego County. (NARA.)

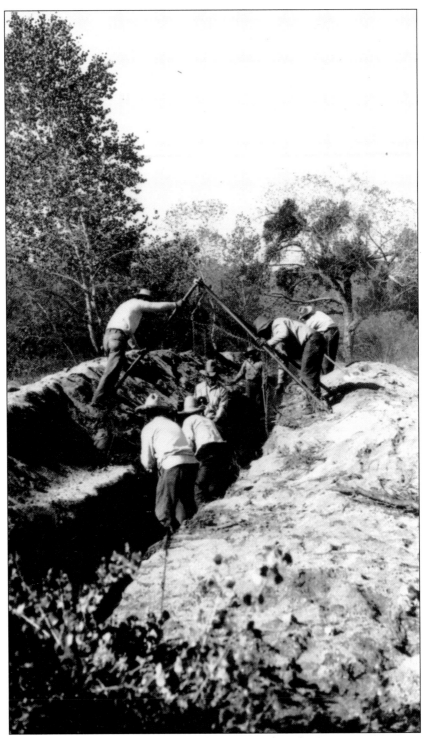

In October 1934, a 12-inch steel pipeline is laid into a trench at the Rincon reservation to direct water for use inside homes. Trenches were dug by hand, and pipe was laid by the manual labor of the Indians. (NARA.)

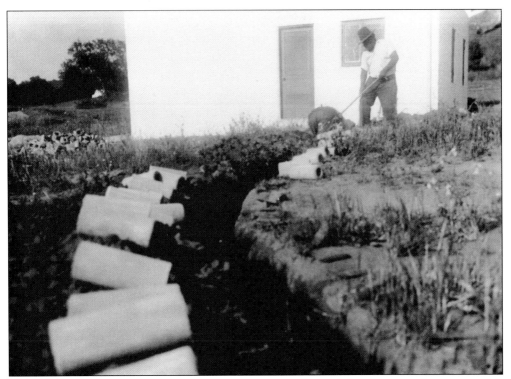

Most Indian reservations are not on a sewage system. Instead they have septic systems with underground tanks and leach lines, which are common in most rural areas. Drain tile is being laid here at the Barona reservation for the septic system of a home. These drain tiles were usually made of clay. (NARA.)

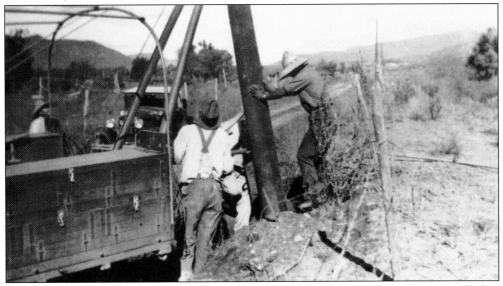

The Rincon reservation was one of the lucky reservations to have their electricity installed in 1934. Poles had to be set before the 2,300-volt transformer line could be installed. The electrical lines at the Los Coyotes reservation were not installed until 1998 because of their location in such a rural area and the high cost of installation. (NARA.)

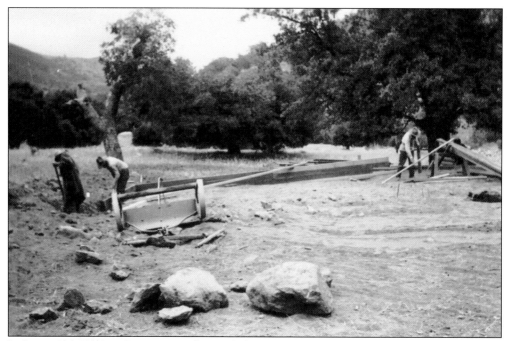

In June 1936, Ed Guachene received some help with the construction of his new home on the Santa Ysabel reservation (above). Once the ground was cleared, leveled, and planned out, the foundation was made, as seen on this home at the Barona reservation in 1936 (below). Note that the Indians were helping each other when building a house knowing that when their home was built, the favor would be reciprocated. (Both, NARA.)

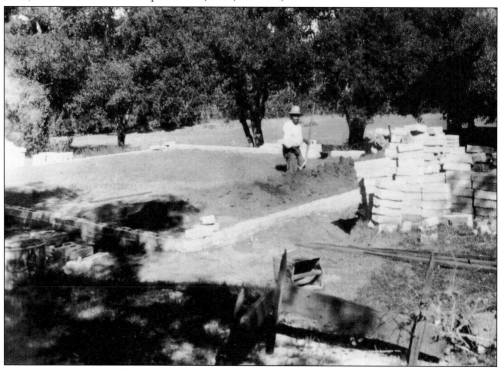

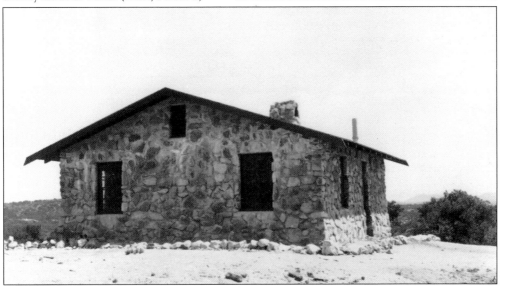

Homes were built of several different materials. At right, a man works on building his house of stone, a material readily available on most of the reservations. Below is Tom Osway's completed home in April 1934 at the Manzanita reservation. None of the homes were built very large, but they were enough to accommodate a family without the luxuries. Stone was great at keeping the homes cool in the summer and warm in the winter. Not all of the homes had glass for their windows, and doors were usually made of wood. (Both, NARA.)

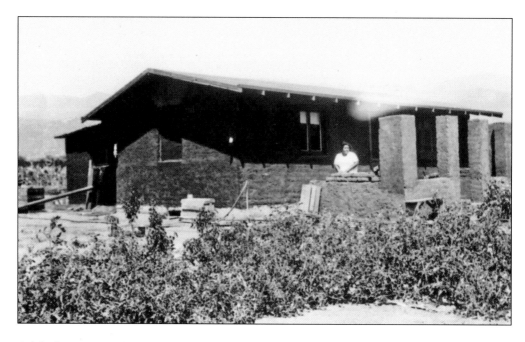

Adobe homes were also good for keeping the inside cool in summer and warm in winter. Above is the home of Macario Calac in 1934 on the Pala reservation. It consisted of only four rooms. George Omish from Rincon, below, received a $275 government loan in 1935 to help pay for materials on his four-room house. The Indian Rights and Responsibilities Program (1935–1946) allowed Indians to acquire government loans to build their homes. Since they provided all the labor, homes could be built with a minimal amount of expense. (Both, NARA.)

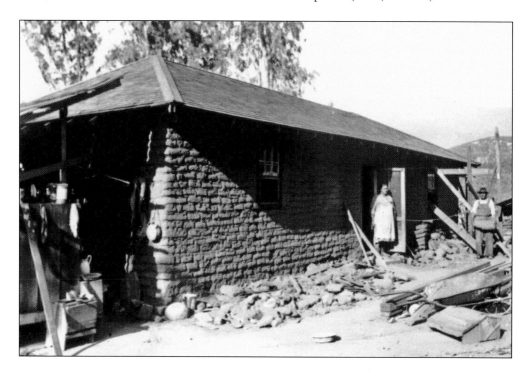

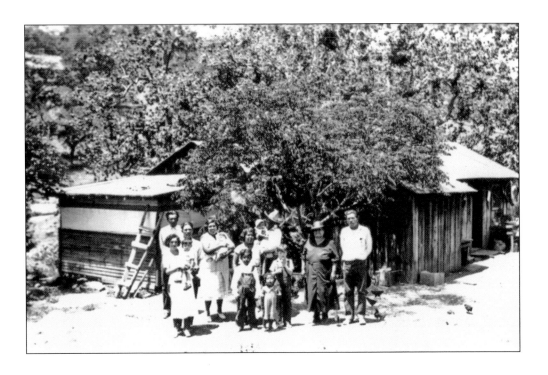

While Ed Guachene's home was being built on the Santa Ysabel reservation (see page 98), he and his family of four lived with two other families in this home, making 14 residents living in this little house. Sharing is common among the Indians. Herman Mendoza (below) had seven people in his family (one was in school and working when this photograph was taken). They all lived in this small home with the Dave Calac family while their home was being built. (Both, NARA.)

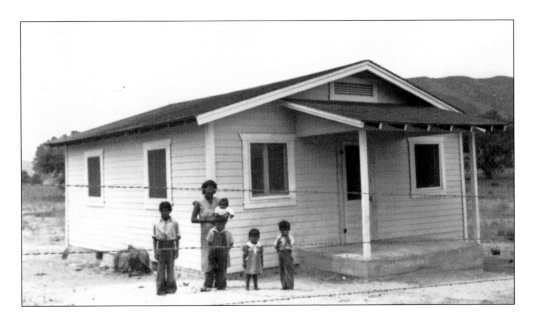

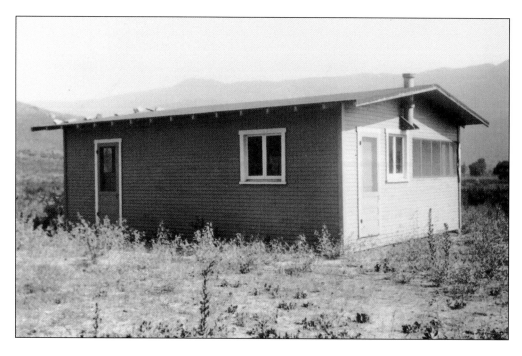

Manuel Siva built this four-room frame house on the Rincon reservation with a government loan of $400. Note that this is a loan and not a grant from the government. They were required to return payments on these loans acquired through the IR&R program (Indian Rights and Responsibilities). Below is Solida Gilbert's new block home, built with a government loan of $350. Later she would get another loan for $100 and build a porch and patio onto the home. (Both, NARA.)

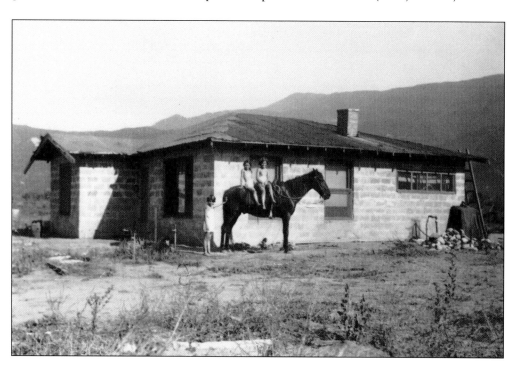

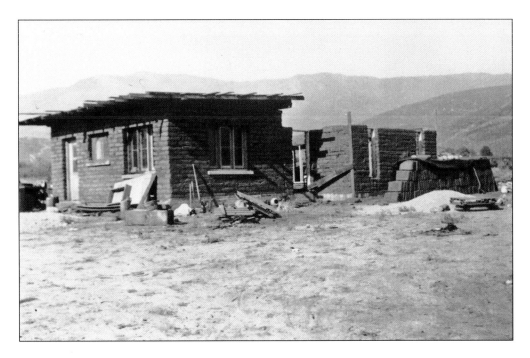

Marcus Golsh received a government loan for $215.40 for materials and built this five-room adobe home for his family in 1935 (above). Below, Rosinda Nolasquez received a government loan for $425 and built this frame home on the Pala reservation. Rosinda was the last survivor of the Cupeño eviction from the village of Cupa who was taken to Pala. The eviction took place in 1903, and this home was completed in 1935. (Both, NARA.)

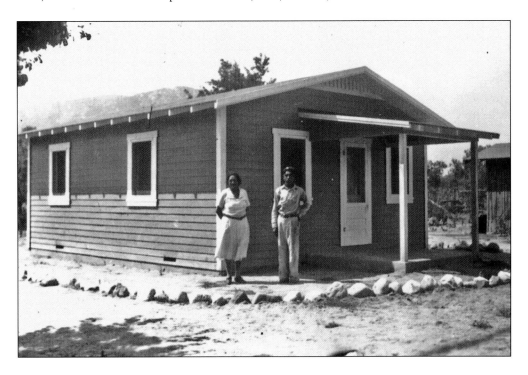

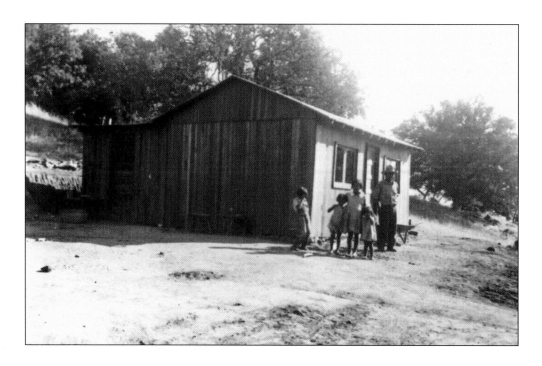

At the Santa Ysabel reservation, William Pablo (above) received a government loan for $98 and built this four-room frame house for him and his four children; it was completed in 1935. In 1936, Steve Lugo completed the home below on the Pala reservation under the IR&R program with a government loan. During the late 1930s, a period of great growth and construction took place on several of the Indian reservations as they improved their living conditions with the government loans. (Both, NARA.)

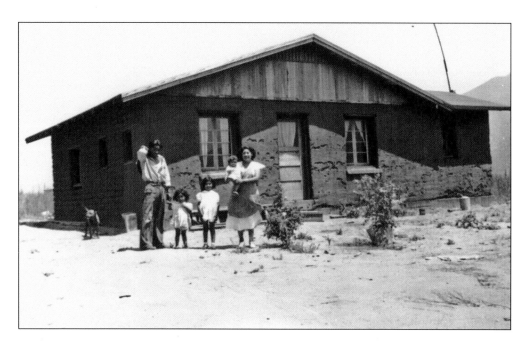

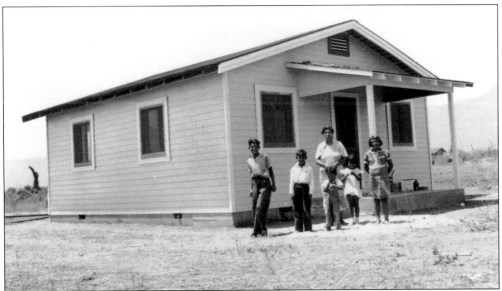

Edward Aguilar completed construction of his new frame home on Mesa Grande in 1937 (above). Also in 1937, on the Manzanita reservation, John Cuero built his frame home with a shingle roof. The completed home measured 22 by 24 feet in size, big enough for his family to live in (right). This was a sufficient size home for their families as Indians were not accustomed to living in large quarters. They only built large enough to fulfill their needs with little to no luxuries. (Both, NARA.)

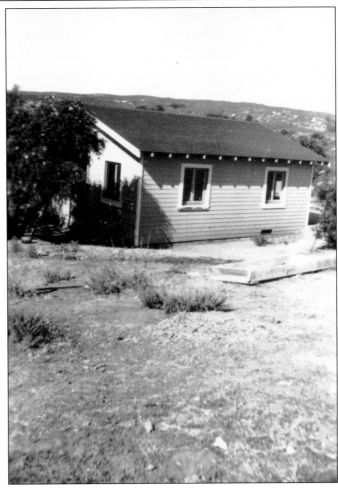

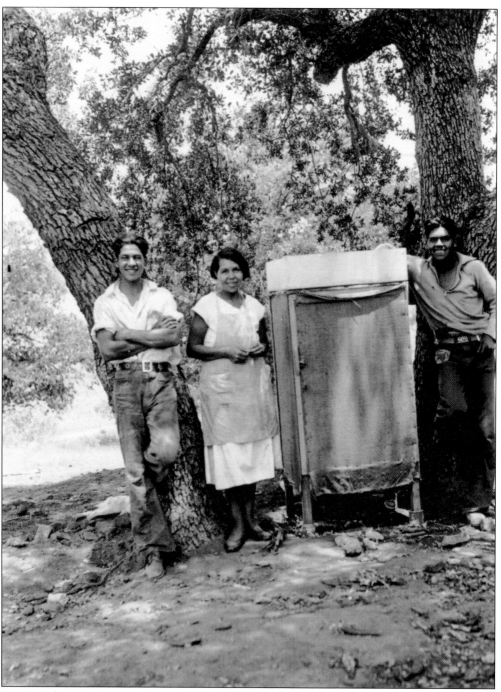

In 1936, John Curo received the first iceless refrigerator for his home. This was considered a luxury. The family is posing with their new treasure, the first one on the Barona reservation. (NARA.)

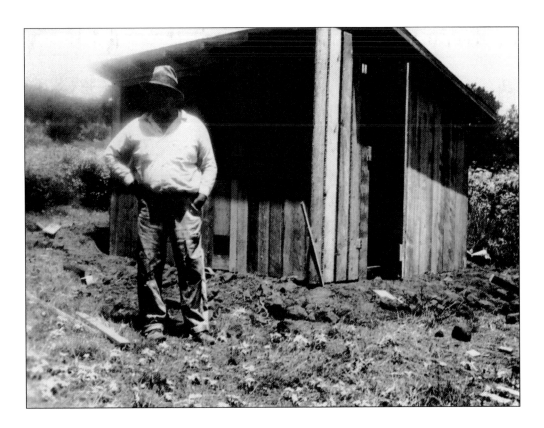

Above is a typical poultry house, built on the Barona reservation in 1936 for the chickens to lay eggs and also for the chickens to be butchered for meat. Below, the Pala Indian reservation sign is finally being constructed in the mid- to late 1930s. This was one of the first signs constructed that informed the public of the exact location of the reservation. (Both, NARA.)

Since the white man taught the Indians how to maintain herds of animals for breeding and feeding their families, several Indian reservations have retained this practice. Above, Hereford heifers are being received and counted at the Barona reservation in 1936. They still maintain a large herd today. Below, cattle are branded at the Baron Long Ranch (Viejas) in 1937. This prevents theft of the cattle and helps to locate ownership should the cattle wander off the ranch. (Both, NARA.)

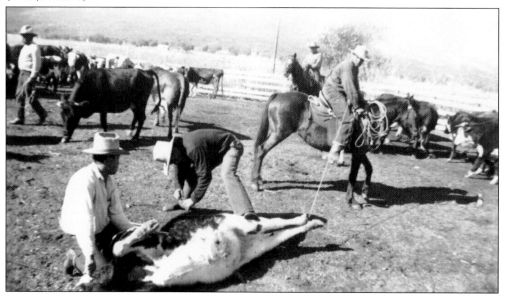

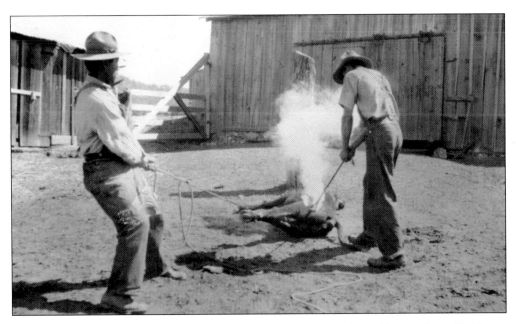

Once all the cattle are accounted for, calves are rounded up annually and branded as well. Above, Stanley R. Davis brands a calf at the Mesa Grande reservation. This is done with a hot branding iron with their registered brand shaped into the metal, which then transfers onto the hide of the animal. Below are Irene Lawson (right) and Grace Dyche (left) with a couple of young calves at San Pascual. (Above, MOM; below, DMT.)

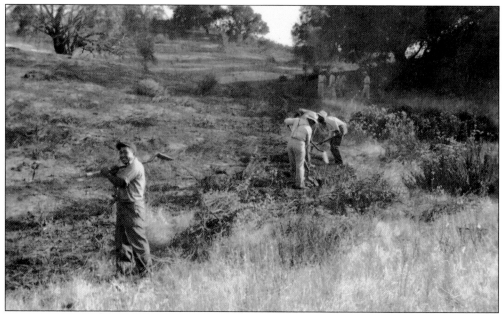

Once the homes are built and the cattle counted, branded, and chewing their cud in the pasture lands, it is time to get to the farming. This supplies not only food for the animals, but for the residents of the Indian reservations as well. The lands must first be cleared of brush, rocks, and trees. Where once the Indians would have burned the brush off the field in a controlled burn, it now must be done with pick and shovel and a lot of hard labor (above). Below, irrigation must be considered for the crops that will be planted. Here the Indians at the Barona reservation pump irrigation waters onto the field. (Both, NARA.)

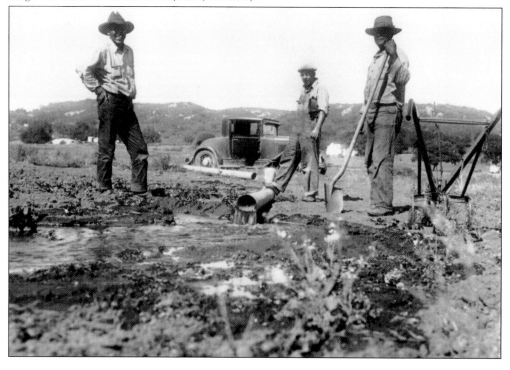

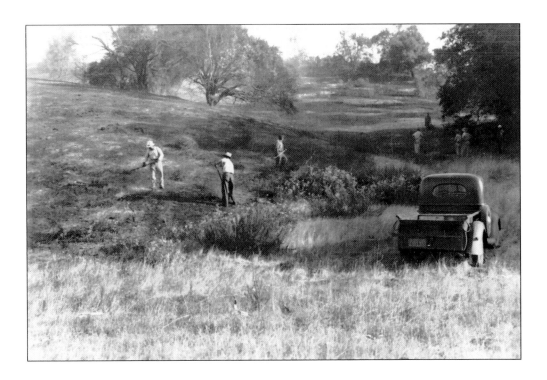

Working in the fields is no easy task and requires many long hours and days. San Diego County Indians were hunters and gatherers and, prior to the arrival of the missions in 1769, had no knowledge of farming or herding. They learned how to tend fields during the enslavement by the Spanish mission padres since they were forced to maintain all the missions' fields and livestock. During this period of reconstruction on the Indian reservations in the 1930s, they tilled their own soil and planted their own fields where land was level enough to do so. (Both, NARA.)

Once the brush was cleared from the fields, the soil had to be loosened (left) and planted in neat little rows (below). Loosening the soil was done with shovels and hoes; this made the rooting system for the plants more viable. Seeds were placed by hand and covered, then irrigated. Irrigation waters would run between the rows in the ditches so as to moisten the roots of the plants without the sun blanching the leaves of the plants, should they be wet when the scorching sun was at its peak on hot days. (Both, NARA.)

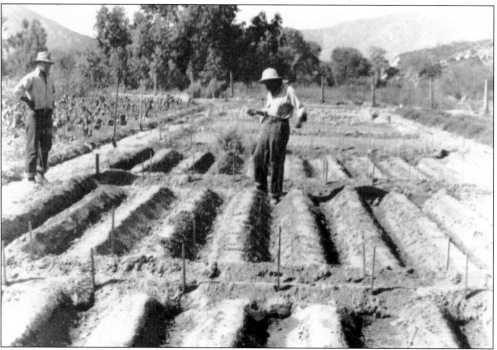

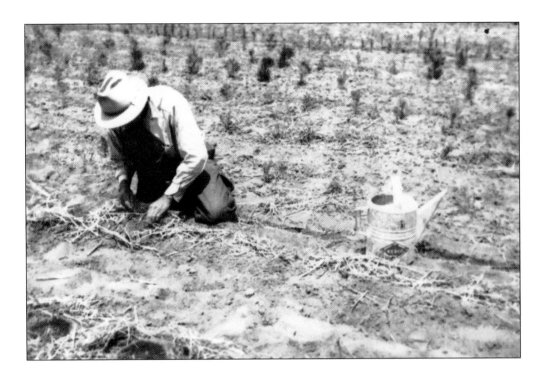

Once the fields were planted, and new plants begin to sprout, they must be continuously tended and weeded (above). Larger fields of grain required farming equipment. Below, Bob Quitac of the Viejas reservation had an oat field and grew 700 acres of grain in 1939. Oats are used for human consumption as well as for livestock feed. Here he is belting—or banding the oats into bales—the oat field. (Both, NARA.)

At left, the Indians of the Inaja reservation are working with a horse and tools to thrash the grain. There is a pile of grain in the foreground. In 1901, this was all done by hand and animal and later by farm equipment. Note that they are actually planting on hillsides because of the lack of available flat lands. Below, on the Pala reservation, they planted orchards of fruits. Here Nicholas Pena is seen in one of the orange groves. (Left, MOM; below, NARA.)

Five

THE 21ST CENTURY

By the 1980s, most of the Native Americans living on reservations were very poor and living in a welfare standard. Few had jobs, and what jobs they did have were unskilled labor. The future looked grim. By 1990, bingo halls were springing up on some of the reservations in tent structures. As time progressed and with a lot of work, these grew into slot machines and card tables, still in tents. As monies were made from this enterprise, buildings began to be built and the rest is history.

Today only half of the Indian reservations in San Diego County have casinos for their livelihood. The poorer tribes are still struggling, but the wealthier tribes are helping those that are not so prominent. Viejas (Kumeyaay) helped pay for the acquisition of electricity on Los Coyotes (Cahuilla and Cupeño) in 1998. And several of the reservations have helped finance clubs for children within their communities as well as nonprofit organizations. Taxes are paid to the state, up to 25 percent of their profits, to help lower the debt in the budgets. The Indians are giving back to the white man, who attempted to exterminate them, enslaved them, and deprived them of their rights and lands.

In the early 21st century, several of the reservation lands of various tribes were decimated by fires, and other tribes donated funds for homes that were lost, to again put roofs over the homeless members. And still they continue to build and rebuild their lands. They no longer acquire lands from the government, as they purchase the lands that were once the homes of ancestors. Pala has purchased a large portion of what was once the village lands of Cupa; Sycuan has purchased additional lands for their reservation up to and including Singing Hills Golf Course, now the Sycuan Resort. Viejas has purchased additional surrounding lands, increasing the size of their reservation.

The Indians are a proud people—the first people, the first nation of this land—and they are slowly re-acquiring their self-respect and giving back to their people, their communities, and their heritage.

The Campo Band of the Kumeyaay Indians runs the Golden Acorn Casino, which opened August 15, 2001. The farthest east of the San Diego County casinos, it sits above Interstate 8 and is called "the luckiest place on earth." On the lands can also be found a truck stop and full travel center for those traveling the highway. (DB.)

KwaHup ("come in") to the Viejas Casino and Resort. The Viejas Band of Kumeyaay Indians started Viejas Enterprises in 1976 with the Ma-Tar-Awa RV park. Now, in addition to the RV park and the casino, they have an outlet center, three radio stations, an entertainment park, a bank, fire stations, and much more. As one of the largest gaming enterprises in the state of California, it donated in excess of $2 million to charitable organizations in 2007. (DB.)

The Sycuan Band of the Kumeyaay Nation can stand proud over their self-reliance acquired through the Sycuan Tribal Development Corporation, established in 2002. In 2003, they purchased the U.S. Grant Hotel in downtown San Diego, which was built by the son of Pres. Ulysses S. Grant. Over $52 million in renovations will complete this historical landmark; funds came from their gaming income. (DB.)

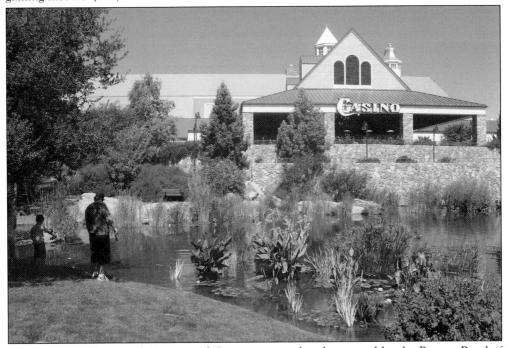

The Barona Valley Ranch Resort and Casino is owned and managed by the Barona Band of Mission Indians (Kumeyaay). One of the most beautifully landscaped of the San Diego County casinos, it started in 1991 with a card room. It then became the first California casino to receive Las Vegas slot machines and by 2007 became the seventh largest Indian gaming operation in the country. (DB.)

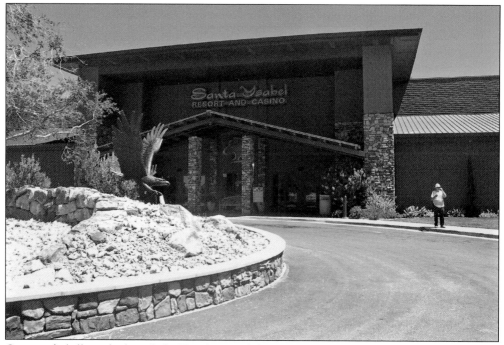

On top of a hill overlooking Lake Henshaw and the surrounding mountains is the enviable view from the newest casino in San Diego County. The Santa Ysabel Resort and Casino opened in 2007 in their 35,000-square-foot facility. Run by the Santa Ysabel Band of Diegueño Indians, they have given much in scholarships ($25,000 in 2007) to education and are hoping that with this gaming prospect they will be able to give much more. (DB.)

On April 18, 2001, the San Pasqual Band of Mission Indians (Kumeyaay) opened the Valley View Casino in Valley Center. In addition to the gaming, they have incredible chefs for great dining and a fantastic buffet. They are currently constructing a hotel next to the casino for guests. (DB.)

Owned by the Rincon San Luiseño Band of Mission Indians is Harrah's Rincon Casino and Resort in Valley Center. In addition to the sophisticated gaming center opened August 8, 2002, they boast a 21-story, 650-room hotel including magnificent suites. This $125-million resort is the fourth Indian casino working in conjunction with Bill Harrah of Harrah's. (DB.)

In May 2001, the Pauma Yuima Band of Mission Indians (Luiseño) opened the Casino Pauma just six miles from the Mount Palomar Observatory in Pauma Valley. Proposed construction will include a 450-room, 23-story hotel; a spa; and a 1,500-space parking garage on 66 acres of reservation land. Surrounded by acres of citrus groves, which have been a mainstay for the band for many years, the casino sets nestled in the groves overlooking Highway 76. (DB.)

The $115-million Pala Casino Spa and Resort owned by the Pala Band of Mission Indians opened April 3, 2001, with the addition of the $105-million, 507-room hotel and an indoor and outdoor spa opening August 10, 2003. It is nestled among the green hills and avocado ranches along Highway 76 in Northern San Diego County. (DB.)

Once known as Singing Hills Country Club in Dehesa, east of El Cajon, the Sycuan Resort was acquired by the Sycuan Tribal Development Corporation. From a health clinic in 1981, to a bingo hall in 1983, to a casino in 2000, and acquisition of Bradley and Big Oak Ranches as well as Singing Hills in 2001, the growth of the tribal assets have continued steadily. (DB.)

Along a dirt road above the casino at the Sycuan reservation can be found the Kumeyaay Community College. Established in 2004, it teaches to both Indian and non-Indian students with courses including Kumeyaay language, Kumeyaay philosophy, and traditional indigenous arts. It is supported by 13 of the San Diego County reservations as well as four principal Kumeyaay reservations south of the United States–Mexico border. (Both, DB.)

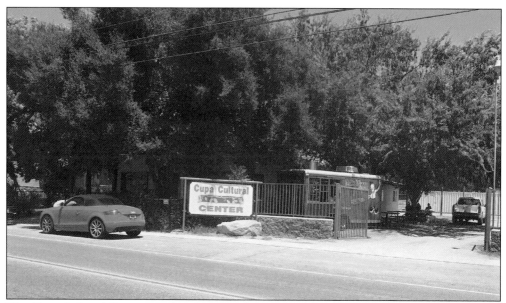

The Cupa Cultural Center was founded in 1974 through the efforts of the Pala community and is dedicated to protecting traditions and preserving the history of the Cupeño Indians from the village of Cupa who came to Pala in 1903. Its small museum displays history of the tribe as well as promoting the annual Cupa Days celebration, which takes place the first weekend of May each year. (DB.)

The Pala Community Center on the Pala reservation sits between the San Antonio de Pala Mission and the Cupa Cultural Center. Community centers such as this can be found on several reservations and provide an entertainment and learning center for the tribal membership. They also serve for a location for council meetings dealing with tribal and band issues. (DB.)

The Barona Cultural Center and Museum opened in January 2000 as the first museum on an Indian reservation and is dedicated to the preserving of the Native American culture of San Diego County. It contains over 3,000 artifacts, a photographic display, and archives depicting the Kumeyaay/Diegueño history and experience. Some of the artifacts in the museum date back over 10,000 years and can be viewed daily by the public. (DB.)

The La Jolla Indian Campground (Luiseño) opened in the 1940s and has provided a family retreat for enjoyment. Indians are very family oriented, and on this retreat, family fun is the center of attention. As well as camping amenities, floating down the San Luis Rey River on inner tubes is one of the many water sports offered. The La Jolla reservation also contains a trading center and, at one time, contained a slot arcade that has been closed down until plans can be completed for a casino in the future. (DB.)

With most of the reservations located in the brushy back hills of San Diego County, fire is all too often devastating to the Indian lands. Many of the reservations have now incorporated their own fire station facilities. In 2001, the Viejas reservation was devastated by fire. In 2003, the Cedar Creek fire caused the loss of 35 homes and two lives on the Barona reservation, 20 homes lost and 70 percent of lands burned at the Rincon reservation, 67 homes lost and businesses burned on the San Pasqual reservation, and five homes lost on the Viejas reservation. (Both, DB.)

Modern fire trucks can be found in the reservation firefighting equipment. Four years later, in 2007, the Poomacha and Witch Creek fires destroyed much more than in 2003. Some 8,960 acres were burned on Capitan Grande, Mesa Grande, Santa Ysabel, Barona, Jamul, and the Inaja-Cosmit reservations. An additional 17,200 acres were burned on the Pauma-Yuima, Rincon, La Jolla, San Pasqual, and Pala reservations. On the La Jolla reservation alone, there were 41 homes and 900 acres of their bison herd lands lost to fire, as well as waterlines melted by the heat. Many of the casinos were used as evacuation points and staging grounds. Homes are now being rebuilt for those that were lost, and lands are being cleaned up. (DB.)

On the San Pasqual reservation, in front of the Valley View Casino, stand these depictions of the Indian family unit. Through all the issues the Indians have had to deal with, family is a very important entity to them. Here, with family spending quality time together, the unity that can be seen among these statues emphasizes the attitudes of the Indians about the family as a whole. (DB.)

Long after the trials and tribulations from the induction of the white man onto the Southern California coasts, through the Spanish and Mexican periods and into the early American periods of history, the Native Americans of San Diego County have had to fight hard to maintain their rights and heritage. As they faced slavery, forced religion, deprivation of their customs and ceremonies, and even genocide, they stood proud and fought hard for the future of their children. Today for the first time in over 250 years, the Indian is again self-reliant, free, and planning a foreseeable future. Once again, they can soar like eagles with the pride and honor of the first people . . . the first nation. (DB.)

www.arcadiapublishing.com

Discover books about the town where you grew up, the cities where your friends and families live, the town where your parents met, or even that retirement spot you've been dreaming about. Our Web site provides history lovers with exclusive deals, advanced notification about new titles, e-mail alerts of author events, and much more.

MADE IN THE USA

Arcadia Publishing, the leading local history publisher in the United States, is committed to making history accessible and meaningful through publishing books that celebrate and preserve the heritage of America's people and places. Consistent with our mission to preserve history on a local level, this book was printed in South Carolina on American-made paper and manufactured entirely in the United States.

Find Your Place in History.